INTIMATE ENEMY

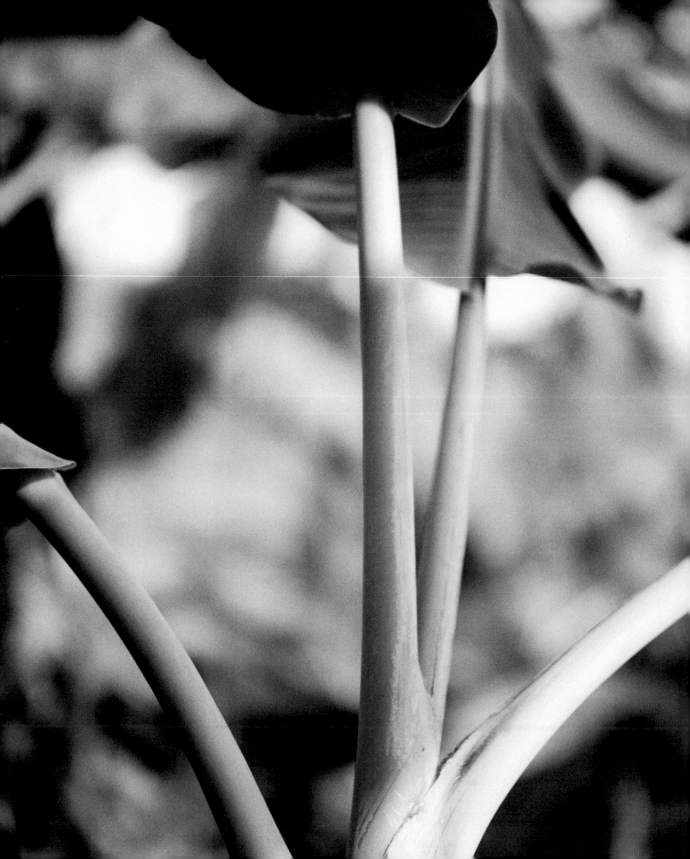

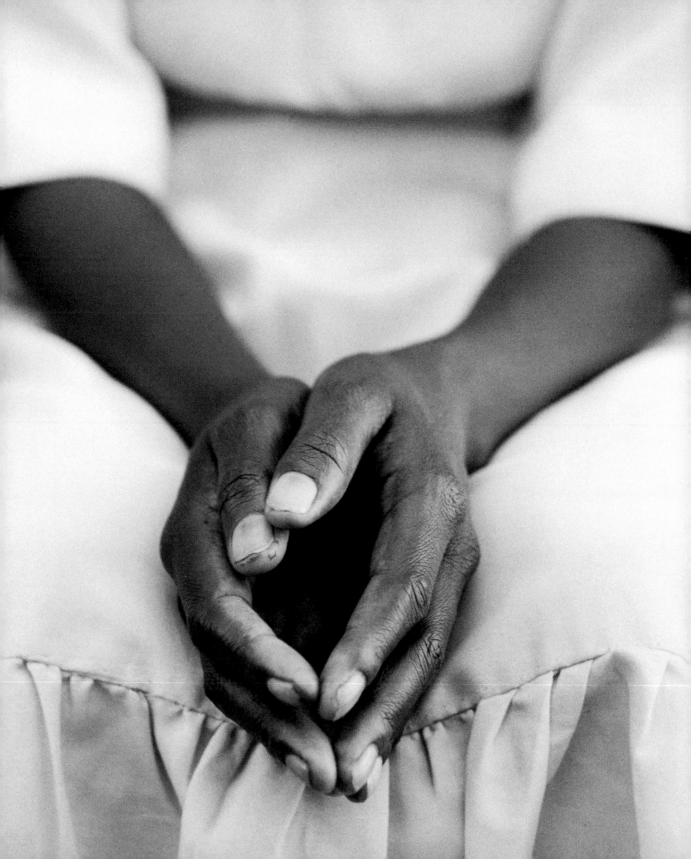

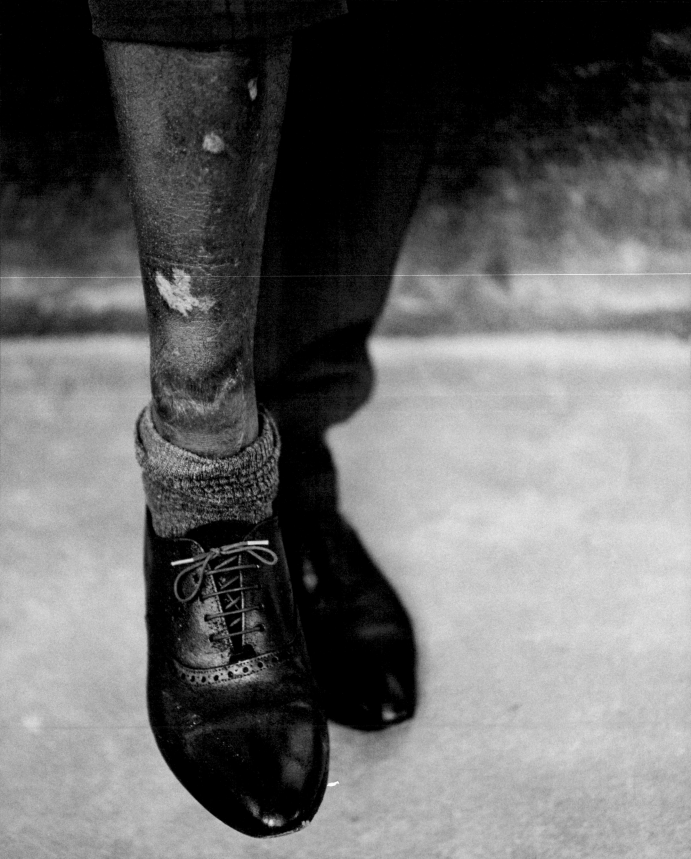

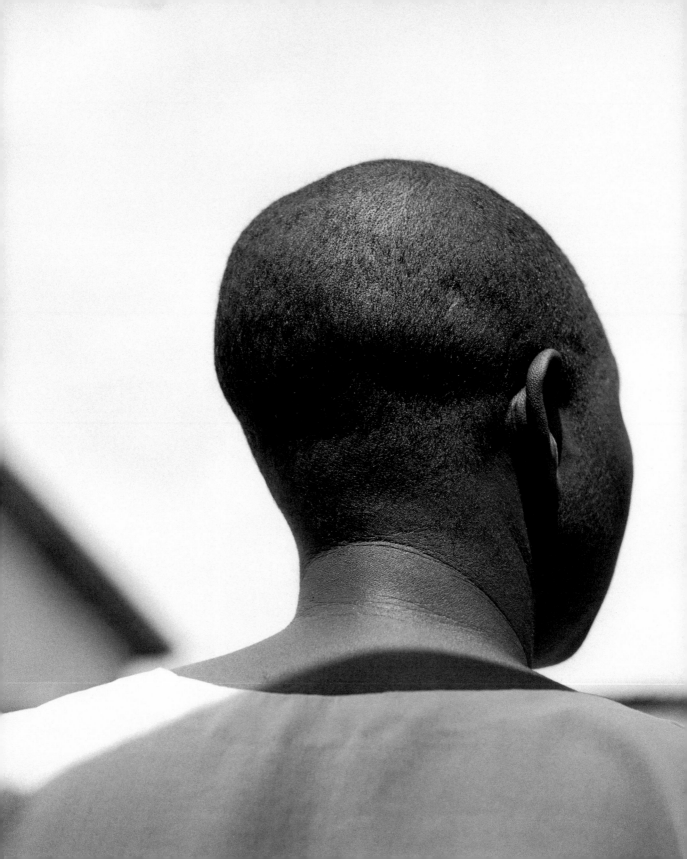

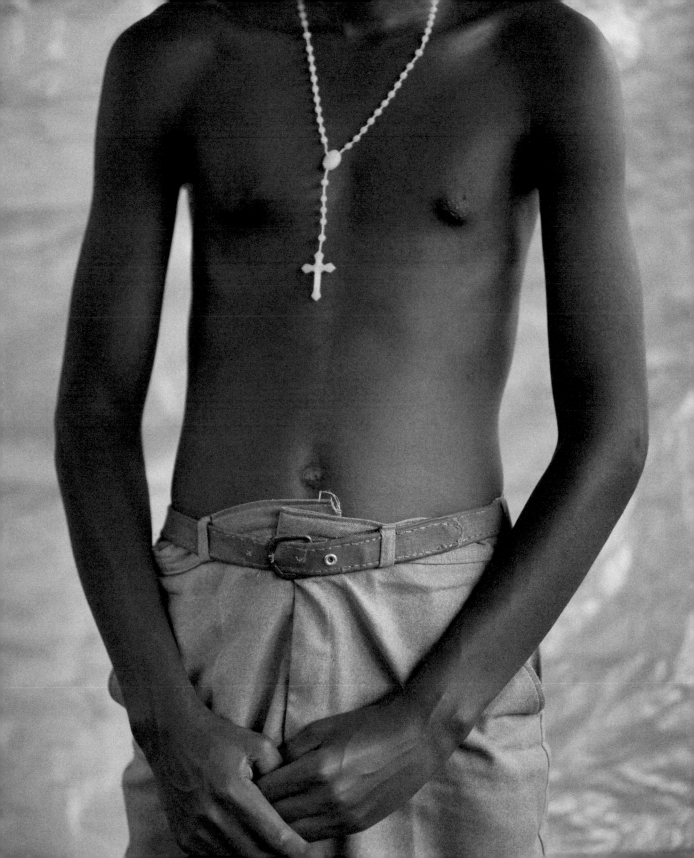

Intimate Enemy

Images and Voices of the Rwandan Genocide

PHOTOGRAPHS BY ROBERT LYONS

INTRODUCTION AND INTERVIEWS BY SCOTT STRAUS

ZONE BOOKS · NEW YORK · 2006

© 2006 Robert Lyons and Scott Straus
Zone Books
1226 Prospect Avenue
Brooklyn, NY 11218

Printed in the United States of America.

Distributed by The MIT Press,
Cambridge, Massachusetts, and London, England

Library of Congress Cataloging-in-Publication Data

Lyons, Robert.
 Intimate enemy : images and voices of the Rwandan genocide /
photographs by Robert Lyons; interviews by Scott Straus.
 p. cm.
 ISBN 1-890951-63-3 (hardcover)
 1. Genocide—Rwanda. 2. Rwanda—History—Civil War, 1994—
Atrocities. 3. Interviews—Rwanda. I. Straus, Scott, 1970– II. Title.

DT450.435.L96 2006
967.57104'310222—dc22
 2005056970

INTRODUCTION

Scott Straus

In 1994, Rwanda, a small state in central Africa, became the site of unimaginable deliberate human destruction. For three months, under the explicit direction of the central state, Rwandans across the country attacked and murdered hundreds of thousands of civilians. The principal targets were members of the country's ethnic Tutsi minority. The state labeled all Tutsis the "enemy," and the killers spared none on account of age or gender. Although some members of the ethnic Hutu majority, in particular the regime's political opponents and those who refused to support the killing, were also targeted, the hallmark of Rwanda's 1994 violence was genocide. The hard-liners who controlled the state aimed to wipe out the Tutsi minority. The weapons were often, though not always, rudimentary, but the violence was unbelievably swift and devastating. In three months, between five hundred thousand and nine hundred thousand civilians lost their lives. It was the most rapid extermination campaign of the twentieth century.*

The Rwandan genocide raises a number of very difficult and important questions. How did this happen? What kind of history could give rise to this violence? Why did the world look the other way when confronted with the kind of violence that many countries had pledged to allow "never again"? How can Rwanda rebuild? How can Rwandans reconcile? How can justice be served? These questions—and many others—have compelled, intrigued, and disturbed many in the last decade, and there is a rapidly growing body of work in print and on film devoted to the Rwandan genocide. The questions surrounding the Rwandan genocide have also inspired many discussions in high-school and college classrooms, as well as real introspection among foreign-policy makers in the United States and elsewhere. The questions the genocide raises, in short, are among the most complex and pressing of our time.

* The exact number of deaths from the genocide is not conclusively known and may never be. The low figure comes from one of the most careful studies of the Rwandan genocide: Alison Des Forges, *"Leave None to Tell the Story": Genocide in Rwanda* (New York: Human Rights Watch, 1999). The larger figure comes from a study conducted by Rwanda's postgenocide government.

This book intervenes in these debates in a quite specific way. It departs from a standard model of scholarly analysis, policy recommendations, and journalistic reportage. Rather, it offers raw images and testimony from those who either participated in the killing or were affected by it. The testimony collected in 2002 comes exclusively from male genocide perpetrators—that is, from Rwandans who have been convicted of committing genocide and who, when interviewed, were serving sentences for their crimes. The photographs taken in 1998, 1999, 2000, and 2001 depict a broader range of Rwandans, including convicted genocide perpetrators, suspects who are in prison awaiting trial, and survivors.

Combined, the testimony and images offer a largely unmitigated and intimate view of the Rwandan genocide. Farmers tell of how they picked up machetes for the first time to kill. They recount the choices they faced, their fear, their confusion, and their rage. Some describe harrowing circumstances in which they were pressured to kill loved ones or in which they felt forced to betray those who had taken refuge in their homes. Others say they were enraged by the war and killed to avenge the death of their president. In these pages, in short, are first-person narratives of ordinary Rwandan citizens who became killers, as well as photographs of perpetrators and survivors. The book does not attempt to make sense of this raw material but allows readers to make their own discoveries.

The book has a second aim that grows out of the first. The Rwandan genocide is a very difficult, even impossible, story to tell. One consequence of this difficulty is that the genocide is often presented in terms and images that are already interpreted and in ways that mystify the violence. This book consciously tries to avoid that, and in so doing amounts to a representational experiment. Allow me to explain. First of all, why is the genocide a difficult story to tell? As a single episode of violence, it is unimaginable. Any single killing incident is difficult—and disturbing—to imagine. It is even harder to conceive of the killing of a family, let alone the hunting down and annihilation of Tutsi civilians from one Rwandan town. But how can anyone—including those who directly witnessed the event—conceptualize a three-month, face-to-face extermination of at least half a million civilians, day after day, town after town? The violence is too vast, too shocking, and too disruptive to imagine.

The genocide is also impossible to narrate in any detail. Why? "The genocide" is in fact an aggregate category, a composite of thousands of acts that occurred throughout Rwanda from April to July 1994. Each incident of violence—each mobilization, each attack, each murder—has a singularity and a specificity that the composite category erases. This is not to deny that genocide took place in Rwanda in 1994: there was a coordinated, state-driven effort to wipe out the Tutsi population. But each killing that contributed to the aggregate episode has a fragmented, often quite local dimension. Such specificity, which is, as we shall see, often bewildering, is frequently missing from accounts of "the genocide."

The difficulty of representing the genocide is apparent in two of the ways the Rwandan story is now commonly told. First, many accounts of the Rwandan genocide focus not on the violence itself—who committed it, where it happened, how it happened, and so forth—but rather on a history of ethnic conflict and categorization in Rwanda, usually dating back to the colonial period. Such a presentation often dwells only briefly on the genocide; the genocide, in fact, serves as the teleological end point, a kind of coda, in a history of conflict. History matters, of course, to understanding the genocide's context (there will be a brief historical discussion below), but in the Rwandan case, teleological history often substitutes for an examination of the violence itself.

The second common way of telling the genocide story is through sensationalism. By now, Rwanda has a standard set of clichéd images: the roadside pile of corpses; the distended bodies floating downstream; the lone machete (or a pile of machetes); the wounded, seemingly lost, survivor. These images and scenes reappear in most film documentaries and on the covers of many books on the subject. They are Rwanda's standard images of horror. Rwanda's state-run genocide memorials do much the same. Throughout the country, the authorities have collected, cleaned, and disinfected the skulls and skeletons of the dead, and arranged the bones in neat rows on tables and on floors. Such are Rwanda's primary memorials of the genocide: carefully collected and organized bones.

The problem with these presentations is that they often sustain the unimaginable nature of the Rwandan genocide. Rather than help people see and contemplate the violence, these presentations obfuscate it. The memorials illustrate this point most clearly: they scare and haunt those who would

enter them. They do not stimulate reflection; they purvey shock and horror and thus paralyze thought. So do the standard images of genocide: pictures of corpses, machetes, and suffering survivors do not encourage their viewers to think. These images are allegories of the genocide that see and interpret the violence beforehand for any who might happen upon it. But rather than open up the violence to be examined, such allegories often preempt and prevent any encounter with it.

We do not pretend that this book will allow readers to *see* the genocide. The violence *is* hard to conceptualize, and any attempt at representation of it will necessarily be incomplete. Moreover, the written testimony is partial: the words are those of convicted male genocide perpetrators, not a cross section of Rwandans. That said, the book is an experiment in trying to see and present details of the genocide in ways that are not already interpreted and categorized and do not sensationalize or shock. In so doing, the book aims to help readers confront unimaginable violence in a manner that stimulates, rather than stifles, reflection.

INTERVIEWS WITH PERPETRATORS

This book is a marriage of two separate projects of disparate origins, one written and academic, the other visual and aesthetic. My project is the academic one. As part of a multistage investigation into the genocide, I interviewed roughly 230 perpetrators in Rwanda in 2002. Most had confessed to their crimes, had been convicted, and were serving sentences in Rwandan prisons. I chose to focus on perpetrators, despite the potential pitfalls of first-person testimonies, particularly those of convicted criminals, because I wanted to interview people who had directly participated in the violence. I did not want to repeat what I had seen too often in the Rwandan context: insiders and outsiders speculating about why men killed. In addition to the prison interviews, the larger research project involved interviews with a cross section of Rwandan witnesses of the violence, including survivors, bystanders, and current and former government officials. The result is an academic book that systematically analyzes my findings to make theoretical arguments about the dynamics of genocide in Rwanda.[*]

There is room for more, however. In particular, the material I collected, especially the perpetrator testimony, has independent value in its largely unmitigated, raw form—that is, as chunks of discourse that can be understood

[*] Scott Straus, *The Order of Genocide: Race, Power, and War in Rwanda* (Ithaca, NY: Cornell University Press, forthcoming).

and thought about in ways that depart from my initial analytic priorities. That was the impetus for this book, which yokes selections of the perpetrator testimony I collected to photographs taken by Robert Lyons.

It is important to recognize that the images do not match the testimony. The Rwandans Robert Lyons photographed are not the ones I interviewed. In effect, the interviews and the photographs represent different subsets of the overall population of prisoners. By bringing the parallel stories together, the book creates accidental encounters that allow readers to confront the genocide in unforeseeable ways. Readers may not need to know much more. Yet the testimony and photographs result from decisions whose details will be relevant for all who try to make sense of what they see and read in these pages. I describe my procedures for obtaining and editing the perpetrator transcripts below, while Robert Lyons describes his work in the Photographer's Notes.

In choosing whom to interview, I sought primarily to generate a representative sample of prisoners. I operated within certain constraints, as befits a contemporary researcher operating under university auspices. Those constraints led me to interview perpetrators who already had been sentenced (rather than those awaiting trial) and those who had confessed to their crimes (rather than those who denied their guilt).

The goal of finding a representative cross section led me in two directions. In choosing whom to interview, I sampled randomly and nationally. The randomness was a tactic to avoid introducing a bias by having others choose whom I would meet. In preparing for this study, I found that prison officials or prisoners always selected particular inmates for foreigners to meet. I also noted that journalists and researchers often interviewed particular individuals or types of people: for example, radio announcers, rapists, and political party members. My objective was different: I wanted a random sample.

My sampling methodology is important for a number of reasons. Most important, the perpetrators whose testimony is collected in this book are not "notorious" *génocidaires*. Rather, most are pedestrian killers: the farmers, fishermen, and carpenters from all around Rwanda who made the genocide possible. Some of the perpetrators presented here were civilian authorities or leaders of the violence. But most were not. Most were the genocide's foot soldiers. These people's stories are still shocking, often for their simplicity and banality. My second central selection principle—sampling nationally—is

important for another reason. The genocide happened differently in different regions of Rwanda. Focusing on Rwandans in only a handful of places risked creating a location-specific impression of what happened, so I interviewed Rwandans from all major regions of the country.

The interview procedure was the following. First, I obtained a letter of permission from the Ministry of the Interior, the government agency in charge of the prisons. I then traveled to each prison that housed perpetrators who had confessed and been sentenced (fifteen prisons met these criteria) and introduced myself to the warden, and eventually we agreed on a date when I would come to the prison to conduct my interviews. I further asked for a list of prisoners who met my selection criteria and for a private office where I could interview the detainees confidentially.

On the chosen date, I generated a set of random numbers from a computer program and assigned them to the prisoners on the list that the warden had given me to determine whom on the list I would interview. In general, I interviewed between three and five perpetrators each day. The "private office" usually consisted of a small room with bare walls and concrete floors. The room would be decorated, sometimes with a chalkboard, sometimes with newspaper pages. Most often, there would be a bench where I would sit with my research assistant, who translated. The inmate sat on a different bench, usually an arm's length away.

I would begin by introducing myself and explaining my research project and my reasons for choosing that person to interview; my translator would then introduce himself. I stressed in my introduction that I was there not to collect information with which to prosecute either the detainee or his accomplices but to understand from that person's perspective what had happened and why. Creating a nonjudgmental atmosphere was critical. I also explained at some length the random part of my sampling. For many of my interview subjects, our encounter was the first time they had met a foreigner, and they wanted to know why they had been selected over all the other prisoners. I gave each person the option of refusing the interview. Very few left.

The interviews varied in length and intensity. Some interviewees had a lot to say about what they had seen, what they had done, and why they did what they did. Others had fairly little to say. Some interviews lasted several hours, even days; others were only thirty minutes long. Such brevity was

rare and usually stemmed from an interviewee's discomfort or resentment at being interviewed or from his inarticulateness. The average interview lasted an hour and a half and resulted in eight to ten pages of single-spaced, typed text. The testimonies reproduced in the book thus represent only a fraction of the total.

With each interviewee, I asked a standard set of questions, as well as spontaneous ones that followed from the perpetrator's statements. Some questions were quite specific, such as how many years of schooling each person had had. Others were deliberately open-ended and vague. Most of my substantive questions focused on how the violence had started in the area where the perpetrator had lived and how he had come to take part in the attacks. In the pages that follow, I include many of my questions (in capital letters). Looking back now, I sometimes wish that, in the moment, I had thought of additional questions to ask or different ways of asking the same question. In other words, I reproduce the questions not necessarily because I am proud of them but so that readers may know to what each interviewee is responding.

The reader will also note that while the photographs are of both men and women, all the interviews are with men. When I conducted my research in Rwanda, women accounted for about 3 percent of the prisoner population. Of those, very few had been sentenced and confessed to their crimes— too small a number, in any case, to randomly sample. My research also showed that while in some cases local elite women had played an important role in organizing and mobilizing others for genocide (in particular, if they had been officials in the government prior to the genocide), overall women played a minor role in the typical attacks on Tutsis. Therefore, I focused on male perpetrators.

In the pages that follow, I do not name those I interview, and throughout the transcripts I suppress any references that might lead a reader to identify victims or other perpetrators. Such concerns with confidentiality are the result of the university "human subjects" guidelines under which I operated. University oversight boards aim to protect the populations researchers study, no matter who the subjects are. Robert Lyons, as an independent photographer, did not operate under the same confidentiality constraints and is not required to disguise the identities of the people he photographed.

Truthfulness is an obvious concern in considering perpetrators' testimony. Can we trust the statements of convicted criminals and, in this case, convicted perpetrators of genocide? There are no easy answers to this question. Readers should remember the position from which the interviewees speak. The *génocidaires* often try to present themselves in the best possible light. At the same time, the perpetrator statements should not be simply dismissed as interested and biased testimonies.

The attentive reader of these pages will find much to learn about how ordinary human beings with no prior history of violence come to take part in a genocide and how they represent themselves. The reader will find a mix of truth, self-interested reconstructed memory, fantasy, exaggeration, distortion, speculation, and lies. How to decide what to believe and how to make sense of the interviews are left to each reader. The book offers a chance for readers to encounter perpetrators' statements, not to have them judged or analyzed in advance.

But I ask that readers, as they assess and consider the statements of *génocidaires,* avoid the temptation to dismiss all the testimony as apocryphal simply because it comes from a convicted perpetrator. I also ask readers to recall the precautions taken when the statements were collected. Confidentiality was key, as was a style of questioning designed to put interviewees at ease and outside the gaze of criminal fact-finding. Moreover, I interviewed only already-sentenced perpetrators, who had fewer incentives to lie outright than would those awaiting trial.

In selecting the text for this book, I chose interviews that conveyed something significant. These are ones that I remember or that I marked as important when I conducted them. I have, of course, edited the transcripts—the contents of this book represent about 2 percent of all the perpetrator testimony I collected. In editing the text, I sought to reduce but not eliminate repetitiveness among the interviews. I also tried to preserve some of the cadences and logical sequences that were common to all the narratives. But overall, each piece of testimony in this book reproduces a particularly memorable moment in my research.

I have organized the transcripts by prison, and for the most part I retrace my progress around the country. The book includes more or longer excerpts

from some prefectures than from others; that reflects the quality of the interview material. I encountered a broader range of perpetrators, or more articulate ones, in some prefectures than in others. Also, my interviewing skills improved over time (more on this below), such that my early interviews (in the Gikongoro and Kigali-Rural prefectures, for example) are shorter and stiffer than later ones (in Cyangugu, Kibuye, and Gisenyi prefectures, for example).

A word on Rwanda's administrative structures, which will be critical to understanding the perpetrator testimony: At the time of the genocide, Rwanda had eleven prefectures (the prefecture is the largest regional administrative unit). Prefectures are divided into communes (equivalent to a county, township, or district); communes are divided into sectors; and sectors are divided into *cellules.* Sectors and *cellules* have no real American counterparts. *Cellules* are run by a committee of four *membres* (members) and one *responsable* (head person); sectors are led by *conseillers* (councilors); communes are overseen by burgomasters, who also have a number of assistants and advisers (such as a commune accountant); prefectures are run by prefects and subprefects. These administrative positions appear throughout the perpetrators' testimony, and for readers' ease I have recorded them in the glossary.

Translation is important and relevant to this book. At the time of the genocide, Rwanda had three principal languages—Kinyarwanda, French, and Kiswahili, in that order of importance. I speak the latter two languages but not the first, so I required a translator. My assistant was a former teacher of mixed ethnic heritage; he is an exceptionally patient, intelligent, and thoughtful man and put interviewees at ease. Because few interviewees had the skills to express themselves in French or Kiswahili, the majority of interviews were conducted in Kinyarwanda. My assistant would translate my questions from French into Kinyarwanda and then the interviewees' responses from Kinyarwanda into French. I then translated the French into English. Undoubtedly, much is lost in any three-language translation. But my assistant and I worked together for hours to get the exact phrasing and meaning right.

In translation, I have sought to maintain some of the rhythm and character of the original Kinyarwanda; on occasion, the language is vague or oddly cadenced. Where this is the case, it represents a purposeful rendering of language on my part, not necessarily a stilted translation: the Rwandan perpetrators often referred to the violence around them in a detached fashion and

often portrayed it as violence without agents. Where possible and appropriate, I have tried to reproduce that character.

Each transcript starts with that perpetrator's particulars, including the sentence he received for the crime he committed. Readers will note that the severity of the penalty does not always correspond to the severity of the crime. That being the case, it is worth briefly discussing Rwanda's justice system, the political context in which it operates, and how so many alleged *génocidaires* wound up behind bars in Rwanda.

In the decade since the genocide, justice has taken three main pathways. First, international trials have been run through the ad hoc International Criminal Tribunal for Rwanda, which the United Nations established in 1994, after the genocide ended, to try the masterminds and others with the greatest responsibility in the killings. That tribunal is based in Arusha, Tanzania, and although it has been criticized for its slow pace, corruption, and occasional ineptitude, it has handed down a number of important decisions. However, the international criminal trials have largely operated independently of Rwanda's domestic justice system.

The centerpiece of Rwanda's domestic efforts was, at least initially, conventional trials. In 1996, the new Rwandan government passed a law to prosecute genocide crimes. That law created four categories of such crimes. The first category consisted of those who had organized or led killings, as well as "notorious" killers and rapists. The second category consisted of those who had killed or had participated in attacks whose purpose was to kill. The third category is infrequently used and refers to those who participated in the violence but did not have the intent to kill. The fourth category refers mostly to property crimes: during the genocide, many Hutus looted Tutsi property, either when Tutsis were killed or afterward. First-category offenders constitute roughly 5 percent of the prisoner population, while second-category offenders account for about 85 percent.

The 1996 law also set the stage for a series of trials to be adjudicated by judges around the country. The caseload, however, quickly exceeded the government's capacity. The genocide devastated Rwanda's justice system; moreover, the government soon arrested more than a hundred thousand detainees being held on genocide-related charges. Any poor, developing country with limited resources and relatively few trained judges and lawyers would have

trouble prosecuting so many. Rwanda's challenge was even greater, given the country's devastation and how complicated and difficult genocide crimes are to prosecute. Even with considerable foreign aid flowing into the country to assist with the trials, Rwanda could not reasonably handle the backlog in a timely fashion.

By 2002, the government had completed only about six thousand cases. At that rate, many calculated, it could take at least fifty years and possibly longer to try all the accused. To compensate, Rwanda introduced an experimental form of community justice called *gacaca,* which literally means "justice on the grass." That system would entail open-air hearings around the country. Before popular assemblies, citizen-judges would hear cases and determine the guilt of the accused. The government's stated aims for *gacaca* were to reduce the case backlog and to contribute to reconciliation. Whether those goals will be achieved is an open question at this stage. The images and testimony in this book originated in Rwanda's conventional justice system. *Gacaca* had not yet started when Robert Lyons took his photographs, and it was only beginning when I recorded these interviews.

In addition to the inefficiency of Rwanda's criminal justice system, there were other problems with the domestic process. One is that sentencing was not immune from political pressure. Indeed, at the first trials, judges often meted out the harshest possible sentences, even to those who had confessed to minor crimes (a confession, all things being equal, was supposed to reduce the penalty). However, as more trials were completed, the judges felt less pressure to deliver the maximum penalty—such justice had already been exacted. Also, Rwandan judges awarded different penalties for the same crime, as is evident in this book. The differences may arise from various factors. Timing often mattered, but so did the particularities of a court, case, or region. In some instances, a survivor's or a perpetrator's family was well connected locally; in others, the judge's confidence in a confession may have influenced the penalty. Sentencing, in short, was often erratic and certainly not always an accurate measure of guilt and responsibility.

BANALITY, INTIMACY, AND HORROR

I am often asked how I responded personally and psychologically to interviewing perpetrators. I hope similar questions may be asked of those who read this

book. The first time I sat in the same room with a sentenced genocide perpetrator I could think of nothing but the fact that this human being had killed another. My questions, as a result, were sloppy and jarring: I wanted to consider only that fact, that moment of murder. After several more interviews, my questions relaxed and my mode of inquiry softened and broadened.

Very soon it became clear that these killers were men who had led quite banal lives before the genocide. They were ordinary husbands, fathers, sons, and boyfriends; they were farmers, fishermen, teachers, and market salesmen. Even more disarming, their testimonies made a certain sense; their rationales were not those of demented, sadistic maniacs. They were narratives of men with a well-developed sense of self-protection. This, of course, is the disturbing conclusion that other scholars who study genocide perpetrators have reached: the aggregate crime is much more extraordinary than those who commit it.*

The testimonies in this book reflect the ordinary, unremarkable nature of most of Rwanda's genocide perpetrators. Their testimonies are simple, mundane, and often full of local contingencies. The events that swirled around them were complex, but many here describe a feeling of being swept up in a tide of unanticipated violence.

I do not want to say much more. The book's purpose is not to interpret or analyze the narratives it contains but to present largely unmediated narratives and images. Through these encounters, readers may thus have experiences of discovery similar to our own and can make of these statements and images what they will.

There is much to learn from the way the perpetrators tell stories, the words they choose, and their representation of historical events. There is much to learn from their facial expressions, their stances, and their eyes. Robert and I do not presume to know what others will find in these pages. These introductory comments are meant only to provide the context necessary to answer basic informational questions about the material.

Over the years, these interviews and photographs have continued to tell us about aspects of the Rwandan genocide that we had not previously noticed, and we return to them again and again. We hope the same will be true for readers, whether they have never traveled to Rwanda or whether they are Rwandan themselves. Both in Rwanda and outside it, there is often little

* See, for example, Hannah Arendt, *Eichmann in Jerusalem: A Report on the Banality of Evil* (1964; New York: Penguin, 1994); Christopher R. Browning, *Ordinary Men: Reserve Police Battalion 101 and the Final Solution in Poland* (New York: HarperCollins, 1992); and James Waller, *Becoming Evil: How Ordinary People Commit Genocide and Mass Killing* (Oxford: Oxford University Press, 2002).

space for the stories and images contained in these pages. The book, therefore, will have succeeded if it opens new questions, stimulates new thinking, and initiates new ways of seeing violence on this scale.

HISTORICAL BACKGROUND TO THE RWANDAN CONFLICT

By and large, the Rwandans whose testimony appears in these pages had little education. None played a major role in planning the genocide. As a result, their testimony is long on first-hand observation and short on context. Without additional background information, their testimony is opaque. This section thus provides some context to explain their references and put their testimony in historical perspective. It offers basic information about Rwanda and a top-down picture of the genocide's origins.

Rwanda is a small, densely settled country with a pregenocide population of some seven and a half million people. The landscape is spectacularly beautiful. Rwanda is about a mile above sea level, and the earth undulates in sets of rolling, bright green, cultivated hills. Hence the country's moniker, "the land of a thousand hills." Rivers and streams cut the hills and drain into deep, blue volcanic lakes in the western region. Rwanda's beauty, incongruous with the genocide's horror, surprises many newcomers to the country.

The economy is overwhelmingly based on small-scale agriculture. The majority of Rwandans grow food and cash crops, especially beans, maize, manioc, and coffee; cultivate banana gardens; and fish. There is no major industry to speak of, save some limited mining operations and cash-crop production facilities. Per capita income before the genocide was about $220 annually, according to the World Bank, and Rwanda has a smaller budget than most mid-sized American cities and major research universities. Today, as was the case before the genocide, foreign donors provide most of Rwanda's annual budget.

The country has three ethnic groups: Hutus, Tutsis, and Twas. These groups' exact origins are the subject of intense debate among experts on the region, and the nature of ethnicity in the region has spawned a large amount of academic literature. A review of those debates is not the task of this introduction, but broadly speaking, before the European colonial period, ethnic identity primarily related to social status and economic activity. Accounting

for some 14 percent of the population, Tutsis tended to engage in animal husbandry and were of higher social status. Hutus, some 85 percent of the population, tended to engage in farming and were generally of lower status. At roughly 1 percent of the population, the third group, the Twas, was more marginal to Rwandan society and primarily engaged in hunting and gathering.

However, even this simple categorization can be misleading. Rwanda's ethnic groups, in particular the Hutus and the Tutsis, differ in important ways from most ethnic or tribal entities. Hutus and Tutsis speak the same language (Kinyarwanda); they practice the same religions; they live in the same regions; they belong to the same clans; and, before its abolition, they paid allegiance to the same kingship. In certain circumstances in the precolonial period, Hutus could become Tutsis; the categories had an element of social fluidity. They were also particular to a specific political system: they took on meaning in the context of Rwanda's monarchy, which was expanding prior to the colonial period. Where the monarchy flourished, ethnic categories were salient; where the monarchy had only recently arrived or was nonexistent, other social categories mattered more than the division between Hutu and Tutsi.

All this changed, famously, under colonialism. European travelers to the region saw racial difference in the Hutu/Tutsi division. Building on then-current anthropological theories, the new arrivals lauded the Tutsis as a finely featured "Caucasoid" race of "Hamites" who had descended from northern Africa to bring civilization to the lowly "Bantu" race of "negroids." The racial interpretation became the bedrock of European colonial rule, first under the Germans but most importantly under the Belgians, who assumed colonial control of the country after Germany's defeat in the First World War. The Belgians apportioned positions and opportunities to the "superior" Tutsis and excluded, at least initially, Hutus from power within the colonial state. The Belgians also introduced national identity cards that labeled Rwandans by their ethnicity. All in all, the effect was to racialize and institutionalize what had been fluid, contextual categories and to make race the central determinant of political power.*

In the run up to political independence, the ethnic hierarchy on which the Belgians had founded their rule began to come undone—for a complex mix of reasons. In the late 1950s, previously excluded Hutu social elites began to mobilize for a more equitable distribution of power in which the Tutsi minority would not monopolize authority and the Hutu majority would have fair access

* A large body of work has addressed ethnicity in Rwanda and the colonial changes to its role. See the following English-language texts: Jean-Pierre Chrétien, *The Great Lakes of Africa: Two Thousand Years*

of History, trans. Scott Straus (New York: Zone Books, 2003); Mahmood Mamdani, *When Victims Become Killers: Colonialism, Nativism, and the Genocide in Rwanda* (Princeton, NJ: Princeton University Press, 2001); Catharine Newbury, *The Cohesion of Oppression: Clientship and Ethnicity in Rwanda, 1860–1960* (New York: Columbia University Press, 1988); Jan Vansina, *Antecedents to Modern Rwanda: The Nyiginya Kingdom* (Madison: University of Wisconsin Press, 2004).

* On this period, see, in particular, René Lemarchand, *Rwanda and Burundi* (London: Pall Mall, 1970), and Newbury, *Cohesion of Oppression.*

to the state, commerce, and education. The challengers' cause won support from European clergy living in Rwanda and eventually from Belgian colonial officers themselves, in particular after the Tutsi elites, who stood to lose from any ethnic redistribution, reacted negatively to the Hutu elites' demands. A tumultuous and violent period followed, and the Belgians eventually helped engineer a power reversal: the Tutsi monarchy was abolished; many Tutsis were expunged from the government and attacked in their homes; and a large number fled into exile. Hutu leaders took control of the state, and Rwanda gained formal independence from Belgium in 1962. This period is often termed the "Hutu revolution," and it was hugely significant in Rwandan history.*

Grégoire Kayibanda, a former journalist and trade unionist and leader of the Hutu social movement, became Rwanda's first president. Born in Gitarama Prefecture, in the south-central part of the country, Kayibanda quickly consolidated his control and brooked almost no formal opposition, either from Tutsis or from other Hutus. In one important incident in late 1963 and early 1964, Tutsis who had left the country returned to launch an attack on Kigali, the capital. The Rwandan armed forces, with Belgian support, rebuffed the attack, but government officials subsequently set out to decimate Tutsi families in certain regions. Several thousand Tutsi civilians were killed, and more fled into exile in neighboring countries. Taken together, the revolution and the massacres seared many Tutsi families, created a large Tutsi exile population abroad, and predicated political rule on an ethnic ideology—Hutus were the majority, so Hutus should rule.

An ideology of Hutu majority rule did not mean, of course, that all Hutus supported the Kayibanda regime or benefited from it. In particular, Kayibanda was seen to favor people from his home region, thus breeding resentment from Hutus who came from the northern and northwestern areas of the country.

In 1973, Juvénal Habyarimana, a military officer from the northwest prefecture of Gisenyi, took power in a coup. He imprisoned Kayibanda, who later died in custody. A number of Kayibanda's closest allies were assassinated. But from the mid-1970s to the late 1980s, Rwanda enjoyed relative stability, economic growth, and favorable treatment from international donors. The period also is one in which, broadly speaking, Hutu-Tutsi relations improved, though the Habyarimana government maintained a quota system whereby Tutsi positions in government and higher education were proportional to their

percentage of the population. The quota system also restricted the opportunities available to Hutus from the southern and southern-central regions, who were seen to have profited under Kayibanda, in favor of Hutus from the northern and northwestern regions.

The main trends in Rwandan politics came to a head in the 1990s, simultaneously and tragically. In 1990, Tutsis living in neighboring countries attacked Rwanda under the banner of the Rwandan Patriotic Front (RPF). The rebels made some initial gains, but with the assistance of the French, the Rwandan army prevented a takeover of the state. Thus began the civil war, during which the rebels eventually gained territory using guerrilla tactics. However, the government often took revenge against Tutsi civilians living in the country, many of whom were arrested or attacked as rebel supporters.

The Habyarimana government and the president's National Revolutionary Movement for Development (MRND), which had been the only legal political party, faced a second, internal challenge. The early 1990s were a period of political change throughout sub-Saharan Africa, and Rwanda was no different in this regard. Under pressure from France—Rwanda's principal international backer—the Habyarimana government ended one-party rule in the country in 1991, and Rwanda's hitherto monopolized political system splintered into several competing parties.

The most important challenger to the ruling party was the Democratic Republican Movement (MDR), whose roots lay in Kayibanda's old party and which had popular support in areas neglected under Habyarimana. The other main opposition parties were the Social Democratic Party (PSD), which had particular strength in Butare Prefecture, and the Liberal Party (PL), which had particular support among Tutsis resident in Rwanda. A fifth important party, the Coalition for the Defense of the Republic (CDR), was formed in 1992. Leaders of the CDR openly campaigned on behalf of the Hutu majority and were renowned for promoting a virulent, unapologetically anti-Tutsi Hutu nationalism.

The ruling elite's response to the threats of civil war and multipartyism set the stage for the genocide in 1994. Hard-liners within the ruling elite branded Tutsis and their supporters the enemy; they financed racist media, both print and radio; they started a youth program—the *interahamwe*—to promote the ruling MRND party; and military officers beefed up the army, imported

weapons, and designed a civil defense program. These would be the essential ingredients of the Rwandan genocide, although exactly how and when they became a plan for genocide remains an open and debated question.

What matters for our purposes is that perpetrators recalled these fragments of recent and distant history. To follow and understand their references—to the Tutsi monarchy, the Hutu revolution, the Kayibanda regime, the 1960s massacres, regionalism in Rwandan politics, racist media, or the opposition parties—readers may refer to this section of the introduction or to the glossary on pp. 179–81.

THE 1994 GENOCIDE

The Rwandan genocide began the night of April 6, 1994, shortly after President Habyarimana's plane was shot down while approaching Kigali. The president's true assassins are not known conclusively, at least not publicly. Suspicion has fallen both on the hard-liners who subsequently ordered and executed the genocide and on the RPF. Nevertheless, the hard-line allies of the deceased president quickly moved to take control of the state. They deployed their resources against the Tutsi civilian population and their Hutu political opponents. The killing spread swiftly and methodically: the murders of high-level politicians were followed by manhunts for Tutsi civilians around the country. Meanwhile, having been nominally committed to a peace agreement known as the Arusha accords, the rebels and the army reengaged in Kigali, where the rebels had stationed a battalion, and in the north, where rebel troops began a major offensive.*

The violence that engulfed Rwanda for the next three months proceeded on these two tracks. On the one hand, the hard-liners set in motion an extermination campaign. They deployed soldiers, political authorities, and militias to kill Tutsi civilians wherever they were, and they mobilized civilian authorities and Hutu men throughout the country to join in. There was initial resistance to the killing in many parts of Rwanda, in particular in areas where the domestic Hutu political opposition was powerful. But through a combination of raw coercion, intimidation, dissemination of fear, and propaganda—among other tactics and incentives—the hard-liners overcame Hutu resistance. The violence that resulted was swift, ruthless, and devastating for Tutsi populations. Tutsis were, as we shall see in these pages, hunted in their homes, in fields, in

* The best overall account of the genocide remains Des Forges, *"Leave None to Tell the Story"*; for a top-down view, see also Linda Melvern, *Conspiracy to Murder: The Rwandan Genocide* (London: Verso, 2004).

banana gardens, and in gathering places presumed safe, such as churches, schools, and government buildings.

On the battlefields, however, the hard-liners were losing. The RPF soldiers consistently gained ground against the government's armed forces and militias, starting soon after the hostilities resumed. By mid-April, the RPF had seized control of important areas in the north and was threatening the capital, forcing the government to relocate south to Gitarama. The rebels finally seized the capital in early July and managed to secure the entire country within a couple of weeks. On their defeat, the hard-liners urged the Hutu population to flee. By the time the rebels had secured the country, more than two million Rwandan Hutu refugees—about a third of the remaining population—had streamed into the neighboring countries of Zaire (now the Democratic Republic of Congo) and Tanzania. Their flight and the defeated army's efforts to use refugee camps as staging grounds for attacks would lead to a new war in 1996 and 1997, when the RPF-led government invaded Zaire to break up the camps. Stories of Hutus' flight to Zaire and experiences of violence there also appear in the pages that follow. Many were arrested in Rwanda after their return from Zaire.

The prison population swelled after the RPF-led government invaded Zaire. Hutu refugees—some of whom had participated in the genocide—streamed back into Rwanda; others fled deeper into Zaire, where RPF soldiers pursued them and slaughtered thousands.* On their return, many genocide suspects were imprisoned; their confessions led to further arrests; and soon Rwanda's prisons overflowed. Of course, not all detainees were in fact implicated in the genocide. Some were falsely accused because others held grudges against them or wanted their property. Indeed, judges acquitted about 20 percent of those arrested in the 2001 and 2002.

Such is the political and judicial context in which the trials unfolded, these photographs were taken, and these interviews were recorded.

* On these events, which are not well known in the English-speaking world, see Marie Béatrice Umutesi, *Surviving the Slaughter: The Ordeal of a Rwandan Refugee in Zaire,* trans. Julia Emerson (Madison: University of Wisconsin Press, 2004).

PHOTOGRAPHER'S NOTES

Robert Lyons

In late 1997, having completed *Another Africa,* a book of photographs with text by Chinua Achebe, I was haunted by the thought that my work in Africa remained unfinished. I reviewed the photographs of sub-Saharan Africa that I had taken over the previous eight years and realized that my encounter with Africa was incomplete. I still had to confront something there. What that was remained an open question. Only later would I come to understand that the Rwandan genocide had profoundly affected my perception and perspective.

I had returned to Seattle in 1994 to prepare an exhibition of my photographs of Africa. During the last days of the genocide, as I worked in my darkroom, I listened—as was my habit—to the BBC. I watched the news; I read the newspapers; I took in as much information as I could about the genocide. It was difficult to look at my work on West Africa while listening to the news from Rwanda. The images from both places, my experiences in Africa and at a distance, did not resonate with each other. As the days passed, I heard more and more reports about the genocide. I became even more confused. Often the media depicted the genocide as "tribal." Print and television news focused constantly on the horror of the killings without contextualizing them. This all seemed quite one-sided: the lack of history, the simplistic, sensationalistic— sometimes even pornographic—appeal to emotion without analysis. With each day my feeling of impotence grew. I understood nothing about the conflict—not even the images. I felt that somehow there must be a way to show the horror of genocide without making sensationalistic imagery. I wanted to explore the space between the victims and perpetrators and the outside world—not to simply demonize the perpetrators. I felt that condemning those responsible for the genocide too easily makes them into the "other" and evades the questions required of each of us as individuals. If the "other" were hardly human,

then it would be easy to say that we would never do this—that it was unthinkable. But it is not unthinkable, as we have seen many times: in Armenia, in Cambodia, in Germany, in Bosnia, in Darfur. Genocide continues to take place, often with impunity.

I now know that those days in 1994 profoundly affected my ideas about what eventually became *Intimate Enemy.* Somehow I knew even then that I wanted to explore the Rwandan genocide from a perspective different from what I had experienced in Seattle. I wanted not only to construct a context in which to view the actual event but also to find new ways of seeing and thinking about the very idea of genocide. When I wrote the initial project description in 1997, I envisioned it thus: *I intend to present the human face of these people and, in doing so, to bring their stories closer to the ones told by those of us who were not directly involved with the genocide…. People are simultaneously archetypes and individuals in this project. In this way and within a specific antisensationalist context, I believe that ideas surrounding healing, reconciliation, and a strong culture of human rights might ultimately emerge.* This remained my point of departure as I photographed.

The very specific subjective and aesthetic parameters of this project were also evident to me from the start. In particular, I wanted to rethink, rework, expose the genre of the black-and-white portrait. My desire was to present human beings seamlessly, without attributing specific characteristics or imposing fixed categories. I saw my portraits as an archive in which individuals would be more democratically represented. As I wrote in my diary when I was in Rwanda: *This is the most documentary project I have ever attempted. I am allowing the images little poetic and emotional space; viewers will have little room for escape.* Through stark black-and-white portraiture, with a limited depth of field and a background obscure in detail but present nonetheless, I wanted to make the audience enter a more intimate space, ask questions, experience directly the ambiguous physical resemblances between *génocidaire* and survivor. Ideally and idealistically, I believed a common humanity would emerge as viewers witnessed the portraits and realized how they had been affected by the genocide. I hoped that the portraits of the living, survivors and perpetrators, would collapse past and present and bear traces of those who perished.

Organizing the project was daunting. It took over eight months of e-mails, faxes, letters, and telephone calls to convince the Rwandan Ministry of Justice to grant me permission to visit and work there. These were long months of waiting, wondering when and how the authorities would finally respond. The complications did not end there. Once I was allowed to enter Rwanda, I still needed, through a fairly elaborate process, to gain access to the prisons. I had to wait for letters to be written to the director of each prison requesting help. Each letter had to be signed by the Minister of Justice and officially stamped by the ministry. I still remember spending three days waiting for signatures in a tall office building filled with uninterested bureaucrats and secretaries. In retrospect, I realize that these letters were vague pleas for help from the Ministry of Justice on my behalf. At each prison, the responsible party would read the request, query me further about the project, and deliberate whether I should receive access and to what degree.

There was also the fundamental problem of language. A translator accompanied me in all my travels throughout the entire project. We developed a good working relationship, but certain limitations still existed. Often he could not or would not ask the questions I posed. We discussed this a few times, and I finally came to realize that there were just certain things that he as a Rwandan could not ask. Our negotiations were long and difficult, but we found a compromise. When we first met, I asked him if he was a Hutu or a Tutsi, and he answered that he was a Rwandan. He had returned from Burundi. I asked this for numerous reasons, especially because I did not want undue problems based on ethnic issues to arise when we were talking to inmates.

Every day we traveled together to a prison, a survivor group, a courthouse, or a prosecutor's office. With letters of introduction and authorization in hand, we pleaded our case and tried to gain access to interview and to photograph. A typical day went like this: we would arrive at the prison in the early morning, and meet with the director for an hour or so. Once we received permission (if not that day, then the next) to enter, a guard would accompany us to the prison doors but no farther. There were no guards inside the prison. There was, rather, a hierarchy among the prisoners themselves. The prisoner in charge of security would greet us, then lead us to the prisoner in charge of inmates. I wrote in my journal about my first visit to a prison:

In the Kigali prison, for example, some prisoners were dressed in pink, others were half-dressed, and still others were in street clothes. Those in charge of security wore yellow berets; those responsible for information had red and white berets...I kept feeling their eyes upon me, some wondering, for some we were simply a diversion, but others with a look that is haunting.... I am interested in arresting time—rather than portraying the fluidity of it here...and to capture that look with my camera.

My prison visits varied in length. Sometimes I would spend up to seven hours in the prison, meeting people, interviewing, finding places to work, understanding the new site where I found myself. I often entered a prison without knowing whom I wished to interview. Even in 1998, information was scant and difficult to access. The only document I had was a copy of the Rwandan laws on genocide that contained the definition of the four categories of imprisonment.

I decided to work with Category 1 and Category 2 *génocidaires*, many of whom were sentenced to death or life imprisonment. Since there was no list of prisoners to consult and thus no way to arrange interviews in advance, I needed to decide on the spot whom to interview and photograph. This was an efficient, albeit problematic, strategy. Although I worked primarily with these prisoners, I also met, along the way, alleged *génocidaires* and minors who were too young to be Category 1 but who had nonetheless participated in the hundred days of genocide. I hoped that somehow the images would ultimately convey how all were connected and affected by these horrible crimes.

Therefore, I have chosen to present the images here without captions. Although the information is present elsewhere in the book, I believe that, as a photographer, I am responsible for portraying people without emphasizing my own preconceptions. I wanted something of each person to come through in the image, to be experienced emotionally and retinally. The more transparent my representation of each individual was, the more opportunity existed for the person's aura to present itself, even if only momentarily. To recognize the aura is to identify the person. Of course I am involved in this process; the photograph is not a "truthful" document. Something of both the subject and the photographer is in these photographs. But by closing the space between ourselves and the "other," we can perhaps begin to ask more critical questions, to

change fixed patterns of behavior, to arrest the impulse that reduces individual strangers to mere savages and, in so doing, conveniently absolves us of complicity in or responsibility for their actions.

Everyone lost in this genocide. It is my hope that these portraits will serve to put a more human face on the tragedy of Rwanda and bring us one step closer to seeing and thinking differently, so that such a loss will never be experienced again.

INTERVIEWS

This excerpt is from an interview with a farmer from Gikongoro Prefecture, in southern Rwanda. During the genocide, he was thirty-five years old and a father of three. He was literate, having finished six years of primary school. He confessed to killing one person and participating in the murders of several others, crimes for which he was sentenced to fifteen years in prison.

The origin of this is the death of Habyarimana. After the death of the president, the Hutu authorities thought that they would lose power. The high authorities in Kigali went to their home areas. When they arrived at their places, these authorities began to tell people that Tutsis are mean. I will tell you that Rwandans, we are like cows. When authorities say move to the left, we move to the left. The authorities made the population believe that the Tutsis would kill us. That is how the war started. HOW EXACTLY DID THIS HAPPEN? The authorities from Kigali met the local authorities, notably the burgomasters [heads of communes], who had never before incited people to kill others…. Afterward, our burgomaster changed his behavior and started to look for others to join him. He called a meeting of leaders from political parties and the local administration, but not everyone. The people who did not go to the meeting had to hide because they had refused to go to the front. Party leaders and the local administration then got the peasants together. There were places where there were meetings, and there were places where we saw others looting, and we joined like that because you wanted things. HOW DID YOU COME TO BE INVOLVED IN THESE EVENTS? I left to go and loot. Hearts changed, little by little, because of what these authorities said. But what you must also know is that there was a famine and one had a need for things.

When I heard that there were people who went to kill somewhere, I went with the group to get things, whether cows or house items. It was like that that the Rwandans killed others. When you arrived there, sometimes you had to participate in the killings. IF YOUR OBJECTIVE WAS TO GAIN THINGS, WHY DID YOU KILL? I went in a group, and I met someone who had detained a Tutsi, but he didn't have a way to kill. I told you that our way of thinking had changed, and so I killed him. If I told you that everywhere I went I was a killer, it would be true. WAS YOUR PARTICIPATION VOLUNTARY? I lived close to the road, and every time they passed, I went with them. WHAT DID ONE CALL WHAT ONE WAS DOING? In this period, everyone was angry because the president had been killed and everyone said that one had to protect oneself. There was no name.... I understood that the enemy was the Tutsis because the president had died. But it was not prepared. Our minds changed because of the events in the country. DID YOU THINK YOU WERE WORKING FOR THE NATION? If the president was killed now, do you think that people would stand with their arms crossed [doing nothing]? There were also cases where neighbors with whom we had conflicts went to another neighbor's place and claimed that such and such a family was Tutsi. EXPLAIN. You sent others to kill your rivals, whom you called Tutsi.

———

This excerpt is from an interview with a Hutu farmer from Gikongoro Prefecture. He owned a "cabaret" — a local bar in a rural area of Rwanda. He was thirty-three years old and the father of five children at the time of the genocide; he had had five years of primary school education. Here he describes how he killed his brother, a crime for which he was sentenced to ten years in prison.

After the crash of the president's plane, the next day, the Tutsis started to flee to the parishes and commercial centers. I was at the parish. My cabaret was right next to the parish, and I found Tutsis there. I asked my neighbors, "Why are you coming here?" They did not reply. I gave them things to drink and eat. After arriving, the Tutsis at the parish formed a group of young people to retrieve their cattle and belongings. The group went to get this material. However, several days later, the youth in this group refused to return. Among them

was a reservist who had a firearm…. My older brother had a Tutsi wife. She was there [at the church] with their children. When he went there, the head of the parish asked for food and beer. He went to get them at a center. [In rural Rwanda, a center is a commercial focal point, often located at a crossroads, and usually where rural markets are held. For this and other terms, see the glossary on pp. 179–81.] But while he was at the center, the burgomaster came and said, "Where are you going with those things?" When my brother explained that the priest had asked for food for the refugees, the burgomaster found the killers and took them to kill my older brother. The group did this. But my brother was not dead; he was in agony. The priest came to see what had happened. The priest then went back to the church to get a car to bring my older brother to a health center. I went to see him there. When I arrived, the burgomaster said, "You, you have brought food for the Tutsis. So that you do not begin again, you take a machete and you have to decapitate your brother." I refused. The burgomaster asked the reservist to force me to decapitate my brother and said if I refused the reservist would kill me. The reservist took me and gave me a machete. He put a gun behind my head and said, "If you do not cut, I will fire." So I cut. That is my crime.

————

The following excerpt is from an interview with an army reservist from Kigali-Rural Prefecture who was twenty-seven years old and single in 1994. The interviewee, who was a CDR party member, had confessed to killing ten people and received a life sentence for his crimes.

WHY DID YOU JOIN THE CDR? When I left the military, I always was in communication with some Hutus, including a leader of the CDR. I saw that the CDR party was for the Hutus and that the CDR party would defeat the PL, which was the Tutsi party. It was like that. I also had some interests. I was given 5,000 FRW to promote the party and recruit new members. If the party won, I could have received other benefits too. BEFORE 1994, DID YOU HAVE ANY TUTSI NEIGHBORS? Yes. AND HOW WERE THE RELATIONS BETWEEN YOU? Before 1990, we were friends. WHAT CHANGED? I saw ID cards and tattoos saying "Vive Rwigema" [Fred Rwigema was a RPF rebel commander, killed in

1990] on women's thighs and for men on the back of the shoulders. I saw that the Tutsi were accomplices.... I was part of a special military police unit around Kigali. We also found ID cards. The cards made in Rwanda were A3, but those made in Uganda were A4. We noticed that many Tutsis in the city had A4 cards and these tattoos. I asked myself how so many could be so informed. These were the signs that made me no longer trust the Tutsis. ALL TUTSIS? All Tutsis. I thought everyone was the same way.... HOW DID THE 1994 MASSACRES BEGIN IN YOUR AREA? I will tell you my confession. I killed people, ten people. I was commanded that the Tutsis were found at [a certain mountain]. I also entered a house and killed one by one. I was with four civilians.... WHERE DID YOU GET YOUR WEAPON? From the military camp. WHAT WAS THE OBJECTIVE? To exterminate the *ubwoko*. They were the ones who shot the president. The soldiers said it was the Tutsis who shot the president's plane.... DID YOU THINK THE TUTSI WERE THE ENEMY? Yes, I thought that the *ubwoko* was the enemy. We were angry about the death of the president. WERE YOU CONFUSED? We knew what we were doing. We installed roadblocks everywhere. There was no confusion. For us, we knew that the RPF had to have killed the president. No one else could have done it. The soldiers installed the roadblocks to check all persons who didn't have identity cards and who had to be *inyenzi*, and we were sure they had killed the president. WHAT WAS THE GOAL OF THIS? It was to kill the Tutsi *ubwoko*. IF ONE KILLED THE TUTSIS, THEN WHAT? I thought that we would hunt down the Tutsis and then the Hutus would remain, alone. WERE YOU IN CONTACT WITH CIVILIAN AUTHORITIES? The top commander called the burgomaster and the *conseillers* to a meeting. They said we had to round up the peasants.... WHY INVOLVE THE PEASANTS? The peasants were the intelligence. SAY MORE ABOUT THE MEETING. I was told to be sure that the *conseillers* and the burgomaster were at this meeting. We were told to put up roadblocks at the centers and on the roads that were frequently used. Everyone who did not have an ID card would be considered an *inyenzi* enemy and killed. DID THE CIVILIAN AUTHORITIES ACCEPT THIS? The burgomasters and *conseillers* accepted. DID YOU HOPE TO GAIN ANYTHING DURING THE GENOCIDE? After the killings on the mountain, I went to loot the houses that were empty. HOW DID YOU EXPLAIN TO YOURSELF THE KILLING OF WOMEN AND CHILDREN? And if the children were not killed, would the ethnic group be exterminated?... We had to kill accomplices so that

they would not increase their forces. After the extermination, the army would continue to fight, along with other peasants.

————

The following excerpt is from an interview with a farmer and builder who was twenty-four with one child at the time of the genocide; he had had six years of primary-school education. The interviewee is from Butare Prefecture and belonged to the PSD opposition party, as did many people in Butare. There was much intermarriage between Hutus and Tutsis in the southern region of Rwanda, and the interviewee had a Tutsi sister-in-law and a Tutsi aunt. He confessed to killing two people, for which he received a fifteen-year prison sentence.

The day after the crash of the president's plane, April 7, we heard on the radio that in other regions massacres had started immediately. On April 19, when Théodore [Sindikubwabo, the interim president] came to the subprefecture of Gisagara, he met with the leaders of the administration. After the meeting, these leaders told us that the Tutsis had to be killed, as in other regions. But when they said this, it was not in a direct fashion, it was through proverbs. FOR EXAMPLE? In a meeting run by the *conseiller,* he told us, "One must look for the *inyenzi* among us and put them to one side." When we left the meeting, the people began to burn Tutsi homes. Then they looted and took cows. The next day, roadblocks were erected to look for Tutsis who moved around in the sector. At the roadblocks, there were only Hutus. When Tutsis arrived at the roadblocks, we asked them for their ID cards, and if we found they were Tutsis, we took the money they had and let them pass. They were fleeing to Kabuye, a mountain where there were no crops. Those who fled to the subprefecture office and health centers were chased away and sent to this mountain. It was there where they were all gunned down; that way, no shots would have to be fired at offices or health centers.… Those who passed through our roadblock fled to this mountain, but [a communal official] came to the roadblock and told us that taking money was not enough. We were told we had to kill them also. He took two men that we had at the barrier, and he killed them in our presence as an example of what we were supposed to do. We began to leave the roadblock one by one, and only several youths stayed there, still

accompanied by [this official]. Around 2 pm, the twenty-three people who had stayed at the roadblock came to find us in our families' homes. They took us, one by one, and made us gather. They went before us, and we went to look in the hills for the Tutsis who had not fled. We went into four houses. We took four men and six children. We took them to a center, where they were killed and thrown into latrines next to a cabaret. They were killed by a soldier who had been demobilized; he was helped by someone who worked at a mill. We went into other homes, and we didn't find anyone. We went back around 4 pm; the others continued and did the patrols because it was their turn. The next day, people were already aware. Whistles were blown and drums were beaten to call people. We met at a center, and we were sent to look again for the Tutsis. Some were found, but the manner of killing them changed. You took a Tutsi, and you asked people in the group to kill him. This was when I was given a child and obliged to kill him. We left this attack to go back home, and around 1 pm, when we arrived at the center, the people who had collected money bought beer; we drank; and we went home. The next day, we were called back in the same way to go to Kabuye. The Tutsi refugees had been shot the night before. When we arrived, we were supposed to look for people who had escaped the shots. We divided into groups, and each group took a different path. Our group found six Tutsis. HOW MANY OF YOU WERE THERE? Many. We were mixed. It was an attack by three communes, one couldn't identify who was who. When we went about 600 meters more, we found bodies of men who had been shot, mixed with cows, sheep, everything was mixed up and killed. Some among us were afraid, and we began to pull back, while others advanced. We who were afraid, we went back. Four days later, the prefect and the burgomaster said that he who sweeps must get rid of the waste, instead of bringing it in the house. They said this because there remained girls who had been taken by young men and were found at their places as wives. It was to say that these women that had been left at the youths' places also had to be killed. We went back, and the next day we went to look for these women because it was known where they were. In our sector, we divided into several groups; the group I was in found three women in three homes. We took them all to a place where they would be killed, and I was ordered to kill one of them. Afterward, I went back. A week later we began to flee because the RPA was already in the region. We fled.... AFTER THE MEETING, WHEN YOU WENT TO THE ROADBLOCK,

WERE YOU CHOSEN OR DID YOU CHOOSE? Roadblocks were ordered to prevent infiltration; they identified where there would be roadblocks in each cell, especially where roads intersected. WHY WERE YOU CHOSEN? I wasn't chosen. Each family was identified, one by one, except families that did not have husbands. ALL MEN OR ONE MAN PER FAMILY? It was one man per home. If there were many from one home, the head of the household would be replaced by a son day after day. But for those without male children, the head of the household would go. HOW MANY ROADBLOCKS IN EACH *CELLULE*? Five. HOW MANY PEOPLE? Ten. WERE THEY THE SAME AS THE ONES WHO DID THE PATROLS BEFORE 1994? No. Before they were Hutus and Tutsis. HOW WERE THE ROADBLOCKS CREATED? A tree was installed on each side of the road, and another tree or a rope was put between them. When you arrived there, you saw it. The people at the roadblock were not visible. We hid because if ever people arrived who were stronger, they would pass. When people arrived whom we could stop, we asked for their ID cards. WAS THERE A *CELLULE* OFFICIAL THERE? There was one per roadblock. If someone was not available, someone else was designated the leader. THE DAY YOU KILLED THE CHILD, HOW MANY OF YOU WERE THERE? About thirty. WHERE DID YOU FIND THEM? In the bush. IN THE SAME *CELLULE*? In the same sector. WHO SAID YOU HAD TO KILL THE CHILD? [A commune official, name withheld.] We were together. DID YOU EVER SEE PEOPLE TORTURED? One person, in a pit, who was not dead. Others were thrown on top of him. DID YOU SEE PEOPLE RAPED? No, but I heard there were rapes. DID YOU HAVE A WEAPON? A club. WERE YOU GIVEN THE WEAPON? We made it during this period. Around the twentieth, after the meeting with the *conseiller*. DID THE *CONSEILLER* SHOW YOU HOW TO MAKE IT? No, Rwandans know how to make them. When we chase animals, we use these weapons.... WHY DID YOU DECIDE TO GO WITH THE ATTACK? You had to go because it was by force. WHAT IF YOU REFUSED? Some who left were hit; they paid; their houses were destroyed. DID YOU SEE THAT? Yes, one family near me. WHEN DID THIS HAPPEN? He refused when they came to our houses to take us by force on the twenty-second. FOR WHICH ATTACK? For the first, at the roadblocks.... HOW DID PEOPLE TAKE YOU? A group came. They entered the enclosure and asked if I was there. I left. I was told, "Don't be afraid, you must come." WHO LED THAT? The three leaders—[the communal official], the *conseiller*, and the demobilized soldier. HOW WERE THOSE WHO WERE SUPPOSED

TO BE KILLED IDENTIFIED? They were neighbors. We knew them. WAS THERE A LIST? No, the ones we didn't know, we looked at their ID cards.... WHY DID YOU CONFESS? I understood that what I did I shouldn't have done. HOW DID YOU UNDERSTAND THAT? I understood that for me it was not hatred that I had for them.

––––––––

The following excerpt is from an interview with a former prefectural official in Butare. Forty-one years old and a father of two at the time of the genocide, and a member of the opposition PSD political party, the interviewee was convicted of taking part in an attack and sentenced to fifteen years in prison.

There was a climate of suspicion that began with the war. Little by little, people stopped trusting each other.... In 1992–94, it was really tense. We began to see some Tutsis send their children [to join the RPF]. WHAT WAS YOUR OPINION OF THE HABYARIMANA GOVERNMENT IN PLACE? It was a dictatorship, but a good dictatorship. BEFORE 1994, IN YOUR AREA, WERE THERE ANY NEIGHBORING TUTSI FAMILIES? There were many. HOW WERE RELATIONS BETWEEN YOU? Very good. WOULD YOU PERMIT YOUR CHILD TO MARRY A TUTSI? Yes. ARE THERE ANY TUTSI PEOPLE IN YOUR FAMILY? Yes, my sister-in-law. AT THE TIME, DID YOU THINK THAT HUTUS AND TUTSIS WERE DIFFERENT *AMOKO*? Yes, one cannot tell lies. There was an emigration. They came from Ethiopia with their cows, and Hutus came from the center [of Africa], but we lived together well.... There was hatred. But this hatred was limited to people who had been educated at school, the intellectuals. Peasants did not know this hatred. DID YOU BELIEVE THAT RWANDA WAS A COUNTRY FOR THE HUTUS? That started with 1959 [the Rwandan Revolution, when the monarchy was overthrown]. First the Tutsis ruled alone, then the Hutus did. HOW DID THE 1994 MASSACRES START IN YOUR AREA? If [the RPF] had not killed the president, there would have been no problem. On the twentieth, there was talk this way and that: "The enemy killed the president. Defend yourself." There was infiltration. DID YOU BELIEVE THERE WAS INFILTRATION? Yes. They had sent people to the hills! They had their pits. [This is a reference to a common rumor that Tutsis had dug pits where they would throw Hutu bodies once the RPF took

over.] Hutus said we could be wiped out.... HOW DID YOU COME TO TAKE PART IN THE KILLINGS? I listened to the government's instructions. We had to safeguard our security in our area. You were afraid. You were afraid. I stayed at my house. I am a Christian.... WHY WERE WOMEN AND CHILDREN KILLED? It is logical. There is an expression in Kinyarwanda: "If you kill a rat, you must also kill the rat in gestation. It will grow up to be a rat like the others."... IN YOUR OPINION, WHAT IS THE MOST IMPORTANT REASON THAT LED YOU TO PARTICIPATE? I was indifferent. I saw that people who had killed the president had committed a crime. They had not thought about the consequences. But I said to my neighbors that [the RPF] created a major problem but killing is not the solution. [My neighbors] said, "If we don't get rid of them, they will not spare us."

————

The following excerpt is from an interview with a literate farmer from Butare who also served as a member of his cellule *committee and was an active MRND political party member. The interviewee's wife, with whom he had four children, and mother were Tutsis. The interviewee confessed to killing one person and leading an attack. He received a life sentence.*

IN YOUR AREA, DID MULTIPARTYISM CAUSE ANY CHANGES? Many. WHAT WERE THEY? Even people who lived together, if they were not in the same party, they became estranged. My older brother belonged to PSD. I was in MRND. We didn't speak. WERE THERE VIOLENT CONFLICTS? I fought with another peasant and had a legal hearing. He won. WHY? We argued. We belonged to two different parties. He asked for my [party identification] card. When I showed it to him, he tore it apart, so I hit him. WHY DID YOU LIKE THE HABYARIMANA GOVERNMENT? Under Habyarimana, there was peace. EVEN WITH THE MASSACRES IN 1992 AND 1991? That was caused by multipartyism. BEFORE 1994, DID YOU BELIEVE THAT TUTSIS WERE *INKOTANYI* "ACCOMPLICES"? I thought the accomplices were in the city. But with my neighbors, I didn't think about it. AT THE TIME, DID YOU THINK THAT HUTUS AND TUTSIS WERE DIFFERENT *AMOKO*? Yes, but there were no problems with that. WHAT IS THE DIFFERENCE BETWEEN THE *AMOKO*? Even if this was not true for everyone, you looked at the nose.... HOW DID THE 1994 MASSACRES BEGIN IN YOUR AREA? The burgomaster was

from my cell. The massacres began in a different sector, but the burgomaster was in the PSD. He went to stop the killings. Since he reacted that way, the gendarmes and the judges looked on him badly, and they began to look for him. WHEN WAS THIS? Near the end of April, the twenty-third or the twenty-fourth. He left his office and went to his home in the country. The captain of the gendarmerie and a military leader went to look for him in [a nearby town] on a Friday evening. They demanded that the population put up roadblocks. They said, "If you don't find the Tutsis, take their cows." They went throughout the sector, and in a center they called for a meeting of all the people and said to look for Tutsis. After the departure of these authorities, there was a group that attacked a Tutsi and took a cow to eat. During the attack, one of the Hutus was killed with a spear. The person who died was found the next day. After seeing he was dead, people changed. They were unhappy. They started to burn houses, kill, and loot. That continued in all sectors. WAS THERE A MEETING? Yes. WHAT WAS SAID? That there had to be security so that the burgomaster could travel freely. WAS THERE ANOTHER MEETING? Yes, but without the burgomaster. WHAT WAS SAID? If the serpent wraps himself around the calabash, to kill the serpent you have to break the calabash. WHAT DOES THAT MEAN? If there were Hutus who hid Tutsis, they had to be killed along with the Tutsis. HOW DID YOU COME TO BE INVOLVED IN THESE EVENTS? I was the head of a roadblock. I was put in charge from the beginning. WHY? It was the law. WHO ISSUED THIS LAW? The military. WHO PUT YOU IN CHARGE? The *responsable,* who was a Tutsi and who fled. At the beginning, everyone was afraid, and we didn't know who was to be killed and who was not to be killed. We heard gunshots in the city, which made us afraid. Tutsis and Hutus hid together. WERE PEOPLE KILLED AT THE ROADBLOCK? Yes, but I was not there. There were some youths who were very active. At some point, the radio said, "OK, now it is safe for Tutsis to come out." Some did. At the roadblock, they were stopped and some wanted to kill them. I said, "No, let's take them to the authorities." We went to the gendarmerie and they were killed there. DID YOU KILL? Me, my maternal uncle hid at my house, and I had to kill him. The soldiers arrived at my house along with the *interahamwe* who were looking for the burgomaster. They found my maternal uncle. They said, "You must kill him or we will kill you." I killed him. Afterward, they still said they would kill me. They put me on the ground with five others. They asked for money, for

14,000 FRW. I gave it…. IN YOUR OPINION, WHAT WAS THE GOAL OF THESE KILLINGS? To discourage the *inkotanyi* who fought for their families. HOW DID ONE EXPLAIN TO ONESELF KILLING WOMEN AND CHILDREN? Weren't they Tutsi? If one said you had to kill the Tutsis, that meant women and children. WHY WERE THEY CONSIDERED AN ENEMY? The enemy was the Tutsi, it was said. The small snake was still a snake. IN YOUR OPINION, WHAT IS THE MOST IMPORTANT REASON THAT LED YOU TO PARTICIPATE? I participated in order to protect my family. If you did not participate, you were killed as an accomplice. If you did not participate and you had Tutsis in your family, it was difficult to escape…. WHY DID YOU CONFESS? I felt first that I had sinned. I first asked for pardon from God, but I found that was insufficient, and so I asked for it from the state. I was never instructed; I asked for paper [on which to write the confession] and I did it voluntarily. I hope these things never happen again.

———————

The next excerpt is from an interview with a petty trader at a market and a farmer of coffee and bananas, who also worked at a local parish in his pre-fecture of Kibungo. A father of seven and forty-six years old in 1994, he had not quite finished primary school, although he was literate. He was sentenced to twelve years.

After Habyarimana's plane crash, we were at the market. The burgomaster came to say, "You should get up. The head of state was killed." The Tutsis who were with us started to be afraid. It was in the morning. There was a home for Major [name withheld]. The neighbors of this major left their commune to attack our commune. They started to burn our houses. The Tutsis from our place fled to a parish. Three days later, the same people came back and were helped by our neighbors, and they left together to attack the displaced at the church. The displaced protected themselves against the attack. The attackers who were repulsed called an *interahamwe* [from a neighboring commune] and the soldiers who guarded the burgomaster. The soldiers and *interahamwe* attacked the displaced at the church, and they shot at the displaced in the church and at the health center near the church. We were not there. HOW MANY DIED AT THE CHURCH? Many! About five hundred. HOW MANY ATTACKED

THE CHURCH? About a thousand people. HOW DID YOU COME TO BE INVOLVED IN THESE EVENTS? The *interahamwe* militia who were the leaders of others came to my place, carrying a list of persons who had not participated. They said, "You, you come with us." They said they would kill us if we refused. They had already started to kill Hutus who were called accomplices. I left with them. We looted. I took a basket of beans. There was another group who attacked the first to return the goods to the owners. This group took me, with the basket of beans.... The next day, since the leader of the *interahamwe* was my neighbor, he took me again. I was with them as a sort of self-protection. We arrived at a place where a man was killing a woman. The one who came to kill said, "You who have not killed must bury this person. If you refuse, we'll kill you also." We buried her. There were seven of us. Afterward, we went back.... WHY DID YOU DECIDE TO GO WITH THE GROUP? To protect myself. HOW WERE THOSE WHO WERE SUPPOSED TO BE KILLED IDENTIFIED? The Tutsi families at our place were known. THERE WAS NO LIST? Not for Tutsis, but for Hutus who did not participate. WHY DID YOU NOT REFUSE? I did not have any money.

———

The following excerpt is from an interview with a police brigadier—the head of a communal police squad—in Kibungo Prefecture. A former sergeant in the army, the interviewee was forty-six years old and had eight children at the time of the genocide. He had a Tutsi wife. He was not a member of a political party, he said, because it was forbidden for soldiers and members of the police to join parties. He was sentenced to life in prison.

HOW DID THE 1994 MASSACRES BEGIN IN YOUR AREA? On Wednesday the sixth, there was a market. I worked there, as usual, in charge of security. I went home. The next day, when I turned on the radio, I heard classical music playing to signal that mourning had begun. I heard declarations in French that the head of state was dead. People were told not to leave their homes. Me, as a head of security, I didn't respect this. I went to the commune office. I contacted the burgomaster. He told me how he had learned of the death, like me. We were talking outside, in front of the commune office. I then went to my office. He went to his office. Several minutes later, a car arrived; in it were a businessman, a *conseiller* of [a particular sector], the manager of a seminary,

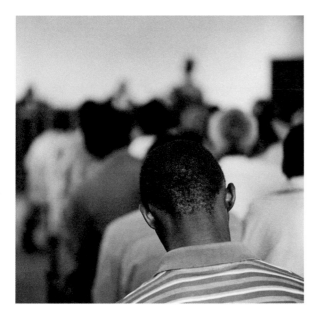

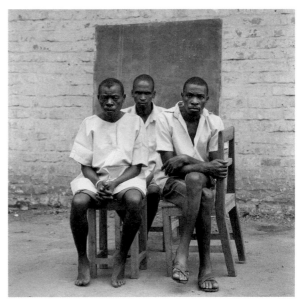

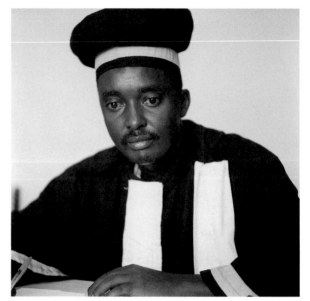

and a member of the *cellule* committee. They went to see the burgomaster in his office. The burgomaster called me while they were still there. The burgomaster told me that this *conseiller* had just told him that the Tutsis from his sector were insulting him, that he could not be patient, that he wanted to kill them, and that in Murambi [in a nearby commune] they had already started. KILLING THE TUTSIS? Killing the Tutsis. The burgomaster asked me, "As a military professional—you are a first sergeant—how do you understand what he just told you, as a person who maintains peace?" I responded that war is for soldiers. I said no policeman would go to a war, nor a gendarme, and that the two maintain public order. I gave them an example. "If a peasant has a problem, he informs the authorities, or he can inform a policeman, and he can have the IPJ [Inspecteur de Police Judiciaire, a commune police officer] follow up on these insults. When it is not at his level, he informs the gendarmes." The *conseiller* did not hear that. He said, "*Voilà*, the one we should go to, he names a Tutsi [the commune's IPJ was Tutsi]." I said he had to let it go, so that it would not be like 1959. The *conseiller* asked the burgomaster for a gun to protect himself. I refused. I was the one who had the key to the area where we kept the weapons. I refused categorically. The *conseiller* shook his head. His attitude changed. After they left, I told the burgomaster, "You see the president is dead. You see that in Gatete's [an MRND hard-liner alleged to have led the killing in Murambi] area the killing has begun, as the *conseiller* said. Won't our commune be attacked by the *inkotanyi,* as we live on Murambi's border?" I suggested that our security would be improved if the soldiers who had gone there returned. The burgomaster went quickly to Rwamagana [a nearby large town] to announce himself to the gendarme commander and to request that the gendarmes restore order. The gendarmes came, eleven of them. As usual, they stayed at the commune office. I organized the patrols. I took the police, and I asked for gendarmes to do the patrols. We went around the commune. In the beginning, we went by the church, and we found people from Murambi there. They had baggage; they were Tutsis. We asked them where they had come from and why they had come. They answered that they were looking for refuge at the priests' place. We helped them. We called the priest, asking him to find lodging for them. The priest agreed. I was with the burgomaster, who also agreed. The priest showed them where to go, and he told us, "If others arrive, I will also welcome them." We agreed, and the

burgomaster told me to designate a post of policemen to keep these people safe. We continued on our way through the commune, through each sector, from right to left. However, we met some resistance from people drinking at a cabaret; they were drinking even though it was forbidden to leave one's house at the time. When they saw the communal vehicle, they ran. When we arrived at a sector neighboring Murambi, we could see houses burning in Murambi. I know these massacres from beginning to end! There were peasants from this sector who had beaten a Tutsi called [name withheld]. On the patrol, we found the *conseiller* of the sector alone on the road. We stopped the car. We asked what the situation was. He said that [the Tutsi man just mentioned] had been beaten. The burgomaster told him to try to find the names of those who had hit him to give them to us so we could arrest them. We continued toward another sector. We found the *conseiller* who had come in the morning beating a Tutsi, a professor from the school of letters in the area. The burgomaster said to the *conseiller,* "You are still carrying out your plans" and told him to stop. The victim was wounded. We brought him to the hospital. I asked the burgomaster to arrest the *conseiller,* the one who was causing the harm. But he didn't. That is our misfortune. We continued toward another sector, and on the way we met a group of people drinking beer. Some ran, others stayed behind, and the burgomaster said, "You have been told not to leave your houses, and yet you drink here." They left. I even fined someone 2,000 FRW for having opened his cabaret. We returned to the commune headquarters. It was evening. I designated a post to keep the church safe. I designated others to patrol beyond the parish. That night, other Tutsis used this patrol to go to the church. The priest welcomed them. The next morning, the eighth, I went to a small market, and I found a woman and a child [from the sector with the *conseiller* who had been beating the Tutsi teacher] and they asked me for refuge. I said, "Where are you coming from?" They told me [the *conseiller*] had killed during the night. While I was listening to them, the burgomaster approached me. He had a woman and her son, who came from a different sector. I asked him, "Where are you going with these people?" He told me they had asked him to help them flee to another sector, where their family was. This is to say that the massacres had started in their sector. The burgomaster told me he would finish what he had started, that he would inform the gendarmes, and he asked the woman and child to continue to the church. I con-

tinued to circulate with the policemen, and I met the priest and asked him how many were at the church. He said that there were about 570, that he was looking for provisions for them, and that he would feed those who had spent the night there first. We continued our activities. When the burgomaster came back, we went to the church. When we left the church, we saw smoke between our commune and Murambi. We went to see what was happening, but before arriving we saw people running to the church, fleeing. In the meantime, we saw someone hiding behind a group of trees. He had thrust a spear into a Tutsi, and the spear went through the person's body. The person who threw it ran, and another Tutsi who was there tried to remove the spear. We stopped. A gendarme and I tried to find the criminal, but we couldn't. We drove the wounded person to the nearest health center, but the director there said he couldn't help him, the wound was too serious. There were two commune vehicles. We looked for a driver for the other vehicle because the burgomaster was driving the vehicle we were in. A driver took the other vehicle and drove the wounded person to the hospital. While we were dealing with the victim, the *conseiller* of another sector and the IPJ came and said it was bad in a neighboring sector. They were in the priest's car. We went toward the smoke we had originally seen. We found a house burning in our commune. The front door was open; the ceiling was burned, and we found no one. We continued to the sector they had said was bad. We found a group that intended to kill or steal cows belonging to Tutsis. They ran when they saw our vehicle. We found the owners and helped them flee to the church. That was the eighth. We continued to prevent these things, but in the meantime, all the sectors had begun to burn, in such a way that I found myself unable to prevent it, especially on the ninth. There was an attack like that of the *inyenzi* in the 1960s, when they attacked three times simultaneously and it was difficult to stop. A person from the health center came to ask for help at the commune, saying that the *conseiller* was killing many people. We went—two police, two gendarmes, and the burgomaster. On the road, we came across a victim who was gravely wounded. We took him and put him in the car to take him to the hospital. When we arrived in the sector, we found that the situation was serious. There was an attack by about three hundred people armed with grenades, machetes, swords, spears, and other weapons. When these peasants saw us, they ran. There were soldiers sent from the army and others on leave.

They approached us as the peasants fled. These soldiers had guns, but they were hidden. The *conseiller* was also there. There were intellectuals, teachers, who had not left when we arrived. The burgomaster addressed the *conseiller* directly, saying "Stop! Stop!" I asked the burgomaster, "Mr. Burgomaster, [the *conseiller*] has been killing people since yesterday. If you authorize it, I'll fire on him." He told me, "If you fire on him, we won't leave here. He is an MRND *conseiller*; you see these soldiers and these peasants. If you fire on him, we'll not leave here, and these refugees will not get away. We must continue to try to calm these people. I will go to Rwamagana to ask the gendarme major to prevent these attacks. With his power, maybe he will authorize something like shooting [the *conseiller*]." He left for Rwamagana. I stayed. When we arrived, we found four people already dead, but others were still alive, hidden around. I stayed with a policeman. The gendarmes left with the burgomaster for Rwamagana. When I stayed, the *conseiller* called back the people who had run. He organized them again to attack the Tutsis who were hidden. What I did was a military intervention: I yelled out in Kinyarwanda and in French (because there were whites there trying to help the victims), "Obedience to the law! Good citizens, leave!" And I shot in the air. The peasants fled. The others left with the soldiers. I was lucky. By the time the vehicle came back from Rwamagana, only one had died. In the vehicle were a major, the burgomaster, and about twenty gendarmes. They saw the dead. The major said, "This is beyond me." So I said to the burgomaster, "There are still people living. We have to try to help them escape." We took them aboard the vehicle and took them to the parish. We left them there...and sent three policemen to the sector we had come from. They had also brought about twelve people to stay at the church. In the meantime, a *conseiller* from another sector called for help. In this sector, the attack came from Murambi. Let me just say that the cause of these massacres was the gendarmes who didn't help us. Even while we were trying to help people, the gendarmes in the vehicle kept telling peasants to keep going, with gestures of support. We learned afterward that they were the ones who distributed grenades. When we got to the church, we learned that there was an attack from a center, so we went with the major, the burgomaster, the IPJ, the gendarmes, and the police to prevent it. When we arrived, we found weapons—grenades and machetes—and many people. The major stopped them, advising them not to go to the parish, but his tone was

not authoritative, not the tone of a leader. He said, "Avoid attacking people who have fled." The peasants just whistled to ignore this, to say that it meant nothing. The peasants dispersed, but later they continued their activities. We returned to the church. The burgomaster and the major told the population, "Don't leave here so you don't have problems. We will continue to help you." The IPJ, who was Tutsi, said to the burgomaster, "Help me save my life. I have seen that the peasants have become very violent." And, indeed, when the major had talked to the peasants, they had said, "Give us that IPJ. He is Tutsi." We gave him the vehicle and the police to drive to his brother's place in Rwamagana; his brother was a priest. The major also left with someone from the church. He took her to Rwamagana. We went to eat. At the church, one policeman stayed. Later he came to find me, saying that an attack was coming and he needed help. Then I heard noise from grenades, near the church. I put the policemen who were there in a combat formation. We went toward the church. I shot one of the attackers. Some fled, carrying the one I had wounded. Others had weapons. There were officers who pushed this attack: soldiers and others who were no longer in the service. After I shot that person, the situation was still calm. It was the ninth. When the burgomaster came back, I explained to him what had happened. I gave him my opinion, especially regarding the gendarmes. He called the gendarmes and told them, "You came to assure security, but you cause insecurity." He said he would tell the major that they should be fired. He criticized them severely. He asked me if there were any reservists I could trust. I said I would go and see. There were police who had been suspended for economic reasons. We called six in for reinforcements. We then had thirteen policemen. We tried to protect the population. On the twelfth, a peasant who had fled to the parish but who communicated with others in the countryside said an attack was coming. I told the burgomaster, who told me to try to do what I could. It was evening. I asked for help from Rwamagana, and they did nothing, and then the gendarmes whom the burgomaster had criticized revolted and fled. I tried to create an ambush for the attack. When the attack came, I fired, but because soldiers led it, they too fired on us. We abandoned our position to occupy another, but we were afraid of firing because they had a lot of strength, and it was nighttime. We wounded some, but we fled, and the attack continued and killed. They killed at the church on the twelfth. On the thirteenth, I went with the burgomaster

and the police to the church. Those who had killed had left.... A priest told me that he could not spend the night, he was going back to Europe. The burgomaster told me to stay there and he would take the priest. I stayed with some policemen; others left with the burgomaster. Then there was another attack, using grenades and guns. They shot to terrorize. They went into the convent and looted. Some took motorcycles, and the soldiers left again. I returned to the church. I found peasants with machetes there. I shot again, this time at the one who was leading the attack. He died. The others fled. When the burgomaster came back, I told him what had happened. I continued to keep the peace. There were no more attacks. There were still people in the church. Later the population fled to Tanzania. The burgomaster also fled. WHY ARE YOU IN PRISON? [The interviewee starts to cry.] The prosecutor never presented the statements I made. He took me for someone who had led the massacres. It was for his personal interest. It was an injustice. What I told you is the truth.... AND YOUR WIFE? She died. She was killed by the *interahamwe*. When I was going to flee, I met some *interahamwe*. They said, "Aha, this accomplice who prevented us from killing the Tutsis is now fleeing." We headed home. But the RPF soldiers had arrived, and they were doing their own searches. They arrested us, but I ran. My wife stayed, with our four children, and they were shot. WHY DID YOU SAY THAT THE *INTERAHAMWE* KILLED YOUR WIFE? Because they prevented us from fleeing.

––––––

This excerpt is from an interview with a primary-school teacher and father of four from Kigali-Rural Prefecture. At the time of the genocide, he was thirty-four years old and, like others, an active member of an opposition political party. His mother-in-law was Tutsi. Here he describes how he came to take part in the killings, even while hiding Tutsis in his home. He was sentenced to fifteen years in prison.

I went to the roadblocks, like others. Hutus and Tutsis, we were together. WHY GO TO THE ROADBLOCKS? They said everyone had to help with security wherever he was, to protect against foreigners. AND YOU OBEYED? Yes, everyone went. Nothing happened. It was obligatory. And if everyone went and you

didn't go, you were punished—either they hit you or they took your money. I was there several nights, from the eighth to the thirteenth, but during the day of the thirteenth we heard gunshots from a neighboring *cellule,* and there was a Mr. [name withheld] who came to see us at a small center, and he told us that [name withheld] had just been killed. He was Tutsi. We were both Hutus and Tutsis. He said, "You are here. Others have begun to kill Tutsis, and you, you are still together?" One saw in another neighboring sector houses burning. The people who were there did not share the same ideas. Then we saw a change. I told this gentleman, "You, you want to create divisions. Let us go and see if this individual was killed." We left, three of us. We went there. In the meantime, I stopped by my house and I got the weapon [a gun that had been given to him by the commune's police chief] because I did not know what was going on. Later we arrived where the dead man had been killed. He was killed and a bit of earth was thrown on him. It was in a banana plantation near his home. You could see blood. When we were there, we heard noises from his house, and I went there. His neighbors who looted were there, but those who killed were not. I saw those who were looting, but the family had left. After seeing this, I tried to return to where I had been. But on the way back, 300 to 400 meters from [name withheld]'s house, I heard noise from people on the border of our *cellule.* I went to see. Arriving there, I saw a large crowd of people and those I had left where we had been. The leader was the leader of MRND in the sector and also the *responsable.* Between two and three hundred people were there. But both Hutus and Tutsis were there. He said, "We are not all here." He gave the names of Tutsis and Hutus who were not there. "Try to bring them here," he said. Then he told us to make a group of both Hutus and Tutsis because, he said, people who saw the group would not be afraid. It was a system. He chose Hutus and Tutsis from [a certain *cellule*]. After the death of the president, nearly everyone who was not in the MRND was afraid because we thought that the *interahamwe* would revenge his death. He chose me to join the group because I had a weapon. He also told those from our *cellule* to go back to our center. We left. About 300 meters later, we arrived at the house of [name withheld], who sold drinks—banana beer. The *responsable* said first, "Take something here to drink." We were in front of the door. We went inside. HOW MANY PEOPLE WERE THERE? About twenty. They brought bottles. We shared. He called me behind the house. He

said, "The Tutsis who are there must be killed." He also called a reservist who didn't have a gun. He told me it was me who had to kill them with my gun. I said, "No. They gave me the gun but they did not say I had to shoot Tutsis." He said, "Give the gun to [the reservist], who will kill them." I told him, "The gun belongs to me." I also said that I did not have enough bullets. Then he called Hutus one at a time. I went back to sit with the others. Maybe he told the others, "Kill the Tutsis." I do not know. At a certain point, after about ten minutes, he told me to go back again, behind the house. He had his own bottle. He told me, "Sit down. We are going to share this bottle." Then we heard people scream. There were seven or eight Tutsis there. When we went back, we saw people cutting others with machetes. Nearly all the Tutsis had been cut. That was what had happened. Seeing dead bodies is something else. I told my companion to return to our place. The wife of [name withheld] was also called, and she was killed by the same group. We went back to our *cellule*. They didn't know anything. They hadn't seen anything. But when I arrived, I found a group there whose chiefs were a member of the *cellule* and the president of MRND in our *cellule*. In the group there was also an *interahamwe* from our cellule. They had a list on which was written the names of Tutsis in our *cellule*. Also there were goods, bikes, cows, radios, that the Tutsis had brought there instead of being looted by the *interahamwe*. The list was read. They also showed me the list. The list was Tutsis and Hutus suspected of being accomplices. After I saw the list, I unfortunately saw the name of my wife's maternal uncle. He was Tutsi, but he was the *responsable* of the *cellule*, even though he was in the MRND. There were other Hutus who were my friends. I asked myself, "What is going on?" They employed the same system. They said, "Here is someone who is missing. His name is so-and-so. Go look for him." I thought those on the list would be killed, and I asked them what would happen to those on the list. He told me they would be killed. "The Tutsis were killed in other regions. Our *cellule*, our region is the only one that remains where the Tutsi and the accomplices have not been killed." We had amicable relations. I asked the group, "Please let my uncle go." They accepted. There were other Hutus whose brothers were on the list, and maybe they knew that their friends would be killed. They asked for their friends to be left alone. In the meantime, we were on the way to the home of [name withheld]. As many of us had asked for our friends to be pardoned,

they gave us a condition, for these people to be left alone, they had to kill the others on the list. WHO SAID THAT? It was a group, the president of the MRND and the president of the *interahamwe* and another member of the MRND. They told me this: "If they want to show they are with us, they must kill their colleagues." We arrived. I called aside my uncle and the others who had been asked to be pardoned. I said, "Gentlemen, you are going to be killed. The only condition that remains—we tried to ask for pardon for you and it was refused—is that you agree to kill the Tutsis you were with. If you do not agree, you will be killed with them." I asked them, "Do you agree or not?" They agreed. We went back to the home of [name withheld]. Those on the list were placed in a line in front of the others. One took the weapons of those on the list. And those who had agreed killed with the others, with their own weapons. From then on, the killings began. We lived at the border. The massacres began. THAT MEANS WHAT? From that moment, at around 5 pm on the thirteenth, killings went on left and right. At this moment, it had been made clear who had to be killed. Boys and men had been killed. AT THIS MOMENT, EVERY TUTSI WAS KILLED? Automatically! And those who hid them. In other killings, others killed. WAS IT ONE GROUP? No. As I said, everyone had to do the patrols. All men, but it was no longer patrols. It was hunting for Tutsis. First, people were collected to do the patrols. But the idea was to kill. You put up roadblocks. There were groups. They were replaced twice a day. The system was practiced by all men more than eighteen years old but not too old. Authorization had been given. It was no longer a question that the Tutsis had to be killed. In the beginning, we did not chase women and children. AND AFTER? The *conseiller* went to the commune to get his orders from the communal leaders. He said that the women and girls—that all Tutsis without exception had to be killed, except Tutsi women who were married to Hutu men. He led an attack. He did not leave our *cellule.* Then he told us, "And the women and the girls."

————

The following excerpt is from an interview with a driver whose employer was Tutsi. The interviewee was in the MDR opposition party and was from Kigali-Rural Prefecture. He had a Tutsi wife. In 1994, he was twenty-seven, and had finished his primary-school education. He was sentenced to fourteen years in prison.

Immediately after the plane crash, since I parked my employer's car in [a commercial center], the next day they came to see me. I can't lie. There were people who had been trained. Right after the crash, they distributed guns. They came to see me. We went to see my boss. He was not there. He had another car. We went to the market. We began to drink beer. Soon another vehicle arrived. Two vehicles came from the commune. The people in them began to drink beer. There were things in the car, potatoes, rice, and so on. After having drunk the beer, they said, "We're not going to leave this vehicle," [meaning] the one I had parked. "We will bring it to work." They said to me, "Let's go together." I thought there was no problem. I accepted. When we got to the commune, things changed. They took my vehicle. They said, "Since he is from [a particular sector where many Tutsis live], he must be Tutsi."… At the commune, a young man arrived, a younger brother of a [certain] businessman. He told me, "You are here, even though your colleagues were killed. [Name withheld] has been killed." I did not take the road home. I crossed the valley to announce this to the victim's family. When I arrived in my sector, I told the neighbors that people were beginning to be killed in a neighboring sector. We went to announce this to the *conseiller*. But after I said that, a policeman on a motorcycle arrived. The *conseiller* also owned a motorcycle, and they left together.… While we asked ourselves what we could do, others arrived, and they screamed for help, saying another family had been killed. The population was still together then. There had not yet been a separation. Those who were killed first were killed by the youth I have spoken of, the ones who had been trained. We thought that it was people from [a certain sector] who attacked us. We divided into two groups. One stayed by the market. The other left. But immediately many people arrived, in four vehicles, including the one I had driven. In the meantime, we had barred the roads with old pickup trucks. When the vehicles arrived, the people got out and removed the things on the road and they shot in the air and we dispersed. We ran. They began by looting the stores at that center. They transported the things they had looted to the commune office. During all this, Hutus and Tutsis from our area were together. Around 5 pm, the *conseiller* brought worse things because he had called a [certain Tutsi man] and shot him three times. He died right there. Everyone knew what had happened, and that is how people separated. If you had a Tutsi friend, you said, "They are killing Tutsis," and you told him to

hide…. After the fourth day, it was demanded of all people, of all men, to be in the attacks, and anyone who refused was killed. That is how it continued. HOW DID THIS HAPPEN? There was a man. He is here. He went on a hill and called, "All Hutus must come so that we can protect ourselves against the snakes. Those who refuse are like them." DID YOU GO? Yes. No one stayed. The majority of Tutsi men from our sector fled to [a hill in the commune]. We ate their cows. We ate their goats. It was no longer hidden. It was done in the open. HOW MANY DAYS DID YOU PARTICIPATE? You had no place to hide because if you went to another sector, you were killed. DID YOU KILL? Me, personally, I did not kill. You see the work I did in the countryside. I was respected. Those who were respected were behind the others. The others were put in front, to kill. HOW BIG WERE THE GROUPS? I told you four vehicles came, to which were added peasants of about two sectors. If I could estimate it would be about three or four hundred. EVERY DAY THE VEHICLES CAME? Yes, every day…. HOW WERE TUTSIS IDENTIFIED? We were native of the region. There were elders who knew everyone's *ubwoko*. When they arrived in the groups that I spoke of, who were in the patrols, they said, "Let's go to such and such a place. They are Tutsis. They came from such and such a place." And the group went right away. AND ARRIVED AT THE HOUSE? I told you there were people who fled. You could arrive at a house when the family had not yet left. But there were also families where you found old people, weak people, people who were killed immediately. WAS SOMEONE SENT TO GO INTO THE HOUSE? It is difficult to know how to get into a house. Each had two exits. Some went through the first. Others went through the other. WAS THE HOUSE SUR-ROUNDED? DESCRIBE THE METHOD. You see, it was a big group. If they arrived at a family's house, some entered by the main door, others by another door. Some killed. Some took things. It was disorder. One cannot know. DID SOME KILL OR ALL? There were people who were used to it, so you could give them money to kill people that others did not want to kill because they knew them. WHO GAVE THIS MONEY? I will give you an example. There was a neighbor who had hidden in our family. Today he is at my place. Another day he is at your place. Another day he is at another's. Before killing him, the people from the other sector found him when he was coming from the place where had spent the night, to go to another family. They called the people from our sector. They asked, "What shall we do with this person? The person from your sector

must be killed." Because he was a nice man, the people from our sector would not kill him, and they gave money to people from another sector to kill him. It was 500 FRW. WHERE WAS HE KILLED? The person who killed him took a string; he tied it to the ceiling; he put it on his neck; and he was hung. Because he was our friend, after the departure of those from the other sector, we bought a coffin and we buried him…. DID PEOPLE SING IN THE GROUPS? No. COULD YOU DESCRIBE THE MOOD OF THE ATTACKS? WERE YOU HAPPY? WAS IT LIKE A SPORT? We said it was not a problem. As the days passed, people became increasingly habituated. We were no longer afraid, like in the beginning. WAS IT LIKE A JOB? I do not understand. WAS IT LIKE GOING TO WORK? It was like a war. WHAT DO YOU MEAN? You go to work because there is something to gain, but when you went there, for some it was to protect themselves. For others, it was to eliminate their enemies. It was not like a job. THE ATMOSPHERE WAS SERIOUS? It was serious. When one is killing, it is not a game. DID YOUR WIFE SURVIVE? Yes. HOW? She is from Gitarama. The majority did not know her. WAS IT NOT DIFFICULT FOR YOU TO GO TO HUNT TUTSIS WHEN YOUR WIFE WAS TUTSI? It was difficult because my sister had a Tutsi husband and her husband was killed. I had no choice. I had to go with others.

The following excerpt is from an interview with a farmer and carpenter from Kigali-Rural Prefecture. Illiterate, not a member of a political party, the interviewee was thirty-five years old at the time of the genocide. In his telling of events, he describes a remarkable moment when a local official required civilians to line up and hit a dead man—to make sure that everyone had participated in the violence. The interviewee was sentenced to fifteen years in prison.

HOW DID THE 1994 MASSACRES BEGIN IN YOUR AREA? There were not many massacres in our area, not like elsewhere. We heard that the head of state was dead, that his plane had crashed. People were killed after that. AND YOU, WHAT HAPPENED? Even if we are in prison, there are many who did not participate. I was at the house. I was farming. A member of the *cellule* committee came to my place; he said to me, "Let's go! We have to leave together." I asked, "Where are we going?" He said, "Come first, then I'll show you. It's not up to

you to ask where we are going." When I refused, he said, "If you continue to refuse, we'll beat you." So I agreed. I went with him. When he took me, he stopped by other houses, where he got other people. When we arrived at a place, there was someone who came to see someone who had hidden somewhere. There were some among us who went to look for this person in the house of a family, where he was hidden. I stayed with the others. The person was taken. This person was asked where he came from. He told us his origin. Instead of giving his ID card, he said, "I am Rwandan. I don't have an ID card." At the time, there was a law that said that those who didn't have ID cards were *inyenzi.* This member of the *cellule* mentioned this law. The *cellule* member said, "Since you don't have a card you must be killed." Some refused. Some said that because he did not have his ID card, he shouldn't be killed. We the peasants said that. The authorities said the law had to be respected. The member said, "If you refuse, I will kill him." He told the man to lie down on the ground. He hit him twice at the back of the neck and once on the back, and he died. When the member saw he had done a crime, he wanted us to do the same thing. He said, "You too, you have to do something. Everyone must hit him twice with a stick." And we said, "Do we have to hit an already dead person?" He said, "If you don't do it, I'll kill you too." You know that someone who touches blood becomes like a crazy man. So he took a person and said, "You have to hit him, and if you don't do it, I'll kill you." So I did it, but he was already dead. The others did the same thing. Then he said, "Go back home, since you have obeyed."

The following excerpt is from an interview with a tailor and farmer from Kigali-Rural Prefecture. At the time of the genocide, the interviewee was thirty-four years old, a local MDR leader, and married to a Tutsi woman, with whom he had seven children. His level of education was slightly above average. In the excerpt below, he describes how he became a local leader of the violence. He has confessed but not yet been sentenced.

I'll tell you what I know. The plane crashed on April 6; it was a Wednesday. Thursday morning, extraordinary things were said in our sector. I was in the

party administration in the sector, so I could observe the changes better than other peasants. Thursday there was a change. I consider it brutality, or ignorance. My colleagues in the PL in general were Tutsi youths and their families. The PL did not have many members. In the past, when they had wanted to hold a meeting, they invited me and my members to participate to augment their numbers.... [That day] the Tutsis separated themselves in the sector. The youth and the men drank a lot and danced, like it was a festival. In their dance, they said they had won, and they chanted, *"Ikinani cyahanutse"* [indicating, in a slightly derogatory way, that President Habyarimana's plane had crashed]. This created a bad image. It did not show unity. That same day, the communal police canceled the market that was supposed to be held, and in the evening roadblocks were established. There were roadblocks in every sector, at the intersections. In the beginning, the objective was to prevent the enemy from entering. That is to say, we fell into the trap of saying "enemy," which later provoked killings.... WHAT HAPPENED NEXT? After that, it was bad. Starting on Sunday, we saw killings, looting, burning, and the destruction of homes in the neighboring commune.... Later, when I got to where I had my shop, I found the *conseiller*. There was a peasant who asked him a question. The peasant said, "You have to help us in our *cellule*." The peasant said that some neighbors had attacked, someone had been killed, and they were still looting, destroying, and eating cows. The *conseiller* said nothing. We were there. Two vehicles arrived from the communal office. There were youth in them—in this period all people who went into the killings were considered *interahamwe*, so these youths were called *interahamwe*. They got out at the market, and they began to attack the shops. They did not touch the shops belonging to people in the MRND. They hit only the shops of people in the opposition. This is how the machines and the cloth I used were looted. One vehicle went to the *conseiller*'s place, and when I saw that, a lot of things changed. I saw that they had looted all my things. I reflected, and I thought that this would continue and always affect me. I changed my plan. I approached the *conseiller*. I asked him to help me and not to touch my parents-in-law because I had just learned Tutsis were being killed. He gave me conditions. He asked me to stay very close to the family because he could not find excuses to give to his collaborators.... On Tuesday evening, the *conseiller* said that the decision had been made to attack [a neighboring sector] because the people there had not agreed to do

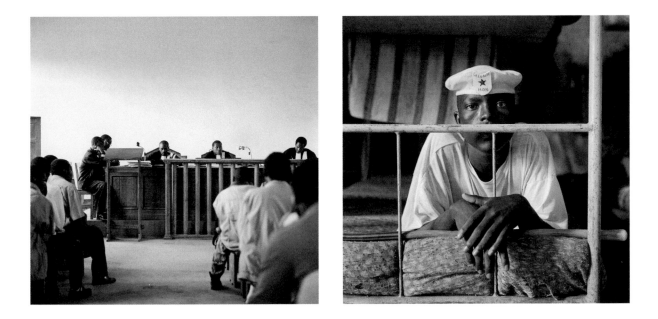

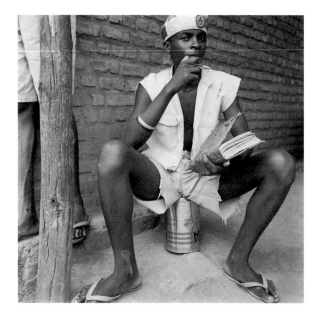

what the others were doing. On Wednesday, gendarmes came, and so did the *conseiller,* and everyone had guns. They put us in front. They showed us the road by which we had to attack. The *conseiller* and the gendarmes went a different way. When we arrived, we found people from different sectors, including the youths who had looted at the market. Some had guns, and they were in front, and the gendarmes and the *conseiller,* who were coordinating the activities, also arrived. They gave directions. We began. These youths with guns began to shoot at peasants in [the neighboring sector], who made a wall near a river.... After we had crossed the river, our attack killed a Tutsi man. Some Hutus from this *cellule* joined our attack. The Tutsis and the Muslims ran toward the mosque, where they had left their families. The youths had used up their bullets and returned to [our sector]. Those of us who had traditional weapons continued toward the mosque. When we arrived there, they were stronger than us, and we fled back to [our sector] again. We went to inform the *conseiller.* WERE YOU LEADING THE ATTACK? When I approached the *conseiller* to save my parents-in-law, I was put among the people in front. I could not refuse this direction to lead. WHY NOT? I was put in front. I was not a leader like someone in the administration; I did not point out who was Hutu and who was Tutsi. WERE YOU IN FAVOR OF THE MASSACRES OF TUTSIS? In reality, what I did was to protect myself, but there was also a certain ignorance because, first, in the period before this, we were opposed to the party in power; that is why we were called the accomplices of the *inyenzi.* The second reason is that when my goods were stolen, I thought everyone saw what would follow. THAT YOU WOULD BE TARGETED? Yes. If I were smart, I would have fled instead of going into the attacks. WHY DID YOU NOT FLEE? That is the ignorance I am speaking of.... After we were repulsed at the mosque, the *conseiller* returned to the commune to get bullets and more people. These were given to him at the commune. They went to the mosque a different way. We saw them from where we were. There were many vehicles and many people in them. They began to shoot and even shot rocket-propelled grenades, which made an explosion. We were afraid. The mosque turned into dust. The sky turned black.... Thursday I arrived at my place. Everywhere I went, I saw no one, but I found a young neighbor at my place, and I asked where everyone was. He told me everyone had responded to the *conseiller*'s invitation for a meeting. I decided to go too.... When I arrived, it was raining lightly. People looked for

shelter near houses, and the *conseiller* was sitting with others in the adminis-tration and with some peasants. That is where the order of the day became clear. In this meeting, there were also some Tutsis. After the rain, a Muslim took an old Tutsi man. He took him before the *conseiller* and before the peo-ple there. He hit him with a pitchfork. He killed him. He came back and took [name withheld] and did the same thing. The *conseiller* was there. If he had not supported it, he would have prevented it. THIS WAS TO SHOW OTHERS WHAT TO DO? An intelligent person can analyze it that way. When we left, 5 or 10 meters away, someone took [name withheld] and said, "You see what is done, tell us what *ubwoko* you are." He said he was Tutsi. He had a machete because everyone had brought a machete to the meeting. Immediately after saying this, he ran. Two youths followed him and killed him not far away. A certain Tutsi man approached me and said, "You see that people are being killed, can't you do something for me?" I told him that I could do nothing but I did not want to be among those who delivered him [to God]. He thought maybe I said that because he had not given me anything. He said he could give me 3,000 FRW. I told him to keep his money and have confidence in God. The next day, this is what happened: the *conseiller* held a meeting in the area where I lived. He ordered that a committee be elected of two people in each *cellule,* and we have four *cellules.* We were there. THE ELECTIONS WERE FOR WHAT PURPOSE? People were confused about who was what *ubwoko,* and we had to have a committee composed of people in every cell who had had a Tutsi ID and who had falsified to become Hutu by changing their ID cards. The elders who knew the lineage of these people were asked to help. In my *cellule,* I was among the two who were elected. There were eight of us in the sector. We elected a secretary under the order of the *conseiller.* DID YOU OFFER TO BECOME A CANDIDATE? Everyone was a candidate. WHY DID YOU ACCEPT? The response is the same: during the war, I could not remain opposed to the *conseiller.* If I had opposed him, I would not be here today. SO FEAR CAUSED YOU TO ACCEPT? Yes, but also ignorance, because I could have fled. After the secretary was elected, the *conseiller* elected a president who was the president of the *interahamwe* in the sector, but, as I said, we did not have *interahamwe* with uniforms; they were youth. There were now nine of us. The *conseiller* coordinated the committee. WHO WAS THE *INTERAHAMWE*? A teacher at a

primary school. The *conseiller* gave us a list of people suspected of being Tutsi and people we had to investigate. We began this work immediately. The ones who were discovered to be Tutsi were killed. BY WHOM? All the Hutus participated in the meetings. All the Hutus were like an army. IN YOUR SECTOR, CAN YOU ESTIMATE HOW MANY THERE WERE? Those who killed or those who looted? BOTH. It would be easier to estimate those who did not participate. For men over fifteen, no more than a hundred did not participate who were not sick. I'll give you an example. Anyone who did not go on patrol paid a penalty. That is where people were killed. The people who killed first, afterward they obliged others to kill. There were people who killed voluntarily and others who were obliged. WERE THE MAJORITY OBLIGED? No. WHY DID PEOPLE WHO KILLED OBLIGE OTHERS TO KILL? When someone refused to kill, they said he was not with them. To be with them, one had to kill.… DID YOU KILL? Yes. WHAT HAPPENED? I was obliged by the *responsable*. He gave me seven children and asked me to lead people to kill these children. It was before the order had been given to kill the women. The three girls, I put them at a cousin's place, but the four boys, we took them and with others we killed them. I killed one of them. The killers that were given to me said they would not be the first to kill. HOW MANY OF YOU WERE THERE? About ten. WHO WERE THEY? Peasants. There was also a teacher. THEY SAID THEY WOULD NOT BE THE FIRST? They said if I did not kill, they would not kill either, and I would not have any explanation to give the leaders who sent me if I did not kill those children.… WHY DID YOU CONFESS? I told you there was ignorance. Afterward, we were taught. I had relationships with people who were killed. I saw that for me, my conscience could not stand what I did. That is why I chose to show my responsibility and the responsibility of all those who participated with me. Also, I want these things not to begin again, and I want to ask everyone for pardon. What I said is about one-half of what I know about the war. It is a lot. There is not enough paper or time.

———

This excerpt gives the testimony of a farmer from Byumba Prefecture, in northern Rwanda. During the genocide, he was thirty-two and the father of one

child, and he had had three years of primary school education. He confessed to participating in several attacks but not to killing anyone himself. He was sentenced to eleven years in prison. Here he describes how the violence started where he lived.

The massacres began after the crash of the head of state's plane. HOW DID THAT HAPPEN? I was with my wife and a girl who had spent the night at my place. We were going to weed the beans. It was morning. The head of state had died the day before, but I did not know that. Some youths arrived, where I was weeding. Thieves had stolen bananas during the night, in our *cellule.* They told me, "You will help us find the bananas that were stolen in our *cellule.*" I left with them. I left my wife in the field with the girl. We went to look for the bananas. We looked in our *cellule.* We didn't find them. We entered a neighboring *cellule.* While we were looking, the president of the commune *interahamwe* came. He found us there, at the home of [name withheld], which was very close to the road. He was accompanied by a soldier people called "Colonel." They were in a vehicle. The head of the *interahamwe* had a gun. He asked us all to come with him. He said, "The head of state is dead, and you, you are looking for bananas?" He told us, "We must look for the Tutsis no matter where they are. The others have already begun to work." Among the people we were with were some Tutsis. We were with them when looking for the bananas. Then a group of attackers arrived, and a young refugee among them killed a Tutsi who was with us. When we saw that he had just killed him, we were afraid. For me, it was the first time I had seen someone die. We wanted to run. The head of the *interahamwe* said that anyone who ran would be shot immediately. He put us in a line, and he marched us on the road. He put us in front; he was behind. He said, "Anyone who leaves this line will be shot." Before we had gone a kilometer, [name withheld] left the line and ran. The head of the *interahamwe* shot twice, then he said, "Let's continue." We arrived at another house. When we got there, a man in our group said he was not Tutsi. So the head of the *interahamwe* said, "If you are not Tutsi, you have to kill this person [indicating a man who was detained at the house]." The man from our group took a club and hit him several times.

———————

This excerpt is from an interview with another farmer from Byumba. The interviewee was single, literate, and a member of the MRND political party. He was twenty-six years old at the time of the genocide. Before the genocide, he had a Tutsi aunt. He confessed to taking part in an attack, for which he received a nine-year sentence.

I began by saying that at the beginning of the war there was no change in relations between Hutus and Tutsis. In 1994, the killings were provoked by the plane crash. I will tell you what happened in my sector. I don't remember the exact date, but it was the night of Wednesday to Thursday. Thursday morning I took a machete to go work on the farm. When I opened the door, I was singing a song, a religious song. It was dawn, around 5:30 am. Before opening the door, I heard someone calling to me from the outside. He called to me. He said, "What are you doing? You sing even though Habyarimana is dead!" He told me how Habyarimana had died, and after that I did not continue my activities. I went back to bed. An hour later, I got up and left the house. I was near the road. I began hearing people talking on the road. Later I went to get water; the road was where the faucet was. There I saw a youth. He was on a bicycle. He was Tutsi. I asked him if he had heard what I had heard. I told him that a man had come to my house to tell me that Habyarimana was dead. He said he hadn't heard that. He continued on. I went to get water and returned home. Around 8 or 9 am, we saw some *interahamwe*, who said that we had to protect ourselves because the *inkotanyi* would kill us. They said, "You have to look for the Tutsis wherever they are." I was in my house, building something. I left to go to my parents'. When I got there, we had an exchange. They asked me what had happened. I told them what I had learned. In our area, there were us four children and our parents. There were six of us. My parents asked us to stay at home because they compared this situation with fighting between [political] parties. We stayed at home until noon, when we saw Tutsi houses burning. There were many people on the road, and some were already dead. I left to go see some girls at a neighbor's house. The girls also asked me not to get into these affairs. But there were people who ran who had spears and sticks. As a hot-blooded young man, I could have gone, but the advice that my parents and friends had given me had scared me. I told myself, "Wait!" Later, when I saw someone go [in the attacks], I hid, because if someone saw you,

they might take you with them. I stayed that way for a week. The next Tuesday, at 10 am, I saw a house burn that belonged to a Tutsi family, and this family was our friend. We saw people outside the house, notably from this family and other Hutu neighbors. I wanted to go down there, but I had to be wary of people who carried weapons. I arrived. They had killed the husband, and the house had been burned. I found the wife, who was near the road, with her children and the neighbors. I spoke with them. She asked me, "You see what the others are doing and you don't do like them. Won't there be consequences for you?" She told me, "The *interahamwe* have just left, and if they come back and find you with your arms crossed like this [doing nothing], you will face consequences for not acting like them." I said that as a Christian I couldn't do what the others were doing. I went home. Now I would like to speak of my participation, of my confession. St. Paul said, "I planned to do the right thing, but evil arrived first." The next day, Wednesday, there was a new Tutsi neighbor in our *cellule*. Until then, he had stayed at his house with his wife and children. Around 3 pm, the gendarmes came down to look for drinks at a center. The gendarmes said, "We have learned that there are accomplices here. Elsewhere people have worked, but here they have not." We lived in front of this center. I heard a gunshot. There was a young Tutsi who was hiding but had left his hiding place to see his friends at the center. It was he who had been shot by the gendarmes. The *interahamwe* came and said, "Since [this person] we had left alone had just been killed, everyone else left must also be killed." Next they came to my house, on the way to a neighbor's. They said to me, "What are you doing? You come with us. We are going to your neighbor's, and no one can stay here." They were led by a policeman, and he had a gun. He hit my leg with his gun. I could not do otherwise. I went. It was around 7 pm. We surrounded the house. We forced open the door. We made them come out. The man was killed. The woman was killed. In this attack, the children were not killed. The next day, we fled.

———————

The following excerpt is from an interview with a farmer from Gisenyi Prefecture who was twenty-five years old and married with one small child at the time of the genocide. A small businessman who had a stall in a local market, he

had had six years of primary education. He had a Tutsi wife—who was not killed in the genocide—but he was a member of the extremist CDR political party. He confessed to killing one person and participating in several attacks. He was given a life sentence.

WERE YOU AFRAID OF THE RPF? Very much. WHY? When they came, we were told that they hunted and beat Hutus, and the refugees from Byumba confirmed that that was true. HOW DID YOU LEARN THIS? From the soldiers who came from the front. They said people were cut open, and two people's intestines were tied together to make a roadblock. When they found someone looking at the people with their intestines tied together, that person was called over, and he was killed too. DID MULTIPARTY POLITICS CHANGE THINGS IN YOUR AREA? Yes. It heated heads. If you were in the PL or the RPF, you took note of those in the CDR and your other opponents. People were afraid of being killed by people from other parties.... Anyone with whom you did not share ideas was not your friend. WHAT WAS YOUR OPINION OF THE HABYARIMANA GOVERNMENT? I tried to travel around the country, even to the capital, and I was informed. It was a good government, apart from those *inkotanyi* who attacked and who supported the Tutsis. I will give you an example. Before the war of 1990, I did not know how to differentiate Hutu from Tutsi. I even had a Tutsi wife. My father-in-law had two Tutsi wives. DID THE WAR CHANGE YOUR VIEWS? Before, I had heard the history of the Tutsis, but I was never interested. With the 1990 war, I began to think about it, but not really. But with Habyarimana's death, I became interested. DID YOU THINK THAT HUTU AND TUTSI WERE DIFFERENT *AMOKO*? It was said that Tutsis were elegant and more intelligent and Hutus were ignorant. DID YOU BELIEVE THAT? There were some youths who were truly elegant. IN THE STREET, HOW DID YOU TELL THE DIFFERENCE BETWEEN A HUTU AND A TUTSI? In general, Tutsis were said to be thin, with long faces and long noses.... HOW DID THE VIOLENCE IN 1994 START IN YOUR AREA? I learned that Habyarimana was shot at 8 am. That morning everyone you saw said, "We have been saying…for a long time that the Tutsis will exterminate us and, *voilà*, they just killed Habyarimana, who was protected. You, the simple peasants, you are finished." CDR and MRND members said this. The first Tutsi killed here was a college professor. He was arrested near a large roadblock when he tried to cross. He had a two-way

radio in his possession. Heads became hot. The youths began to suspect everyone who was Tutsi. They lied to the people being arrested, saying their problem would be resolved at the commune office, and they were brought there to be killed. The Hutus who were not liked by this group faced the same fate. HOW DID THESE MRND AND CDR MEMBERS DELIVER THEIR MESSAGE? They were in the roads, in people's homes, and they even took vehicles by force, saying "Unite! We will take revenge!" HOW DID YOU BECOME INVOLVED IN THESE EVENTS? I was with these people. They came on board a vehicle, and they said, "Let's go!" and we went. AND THEN? There was a man in the vehicle who said there was a Tutsi woman who had given him money not to be killed. It was around 1 pm on the seventh. When we arrived, she said that the money was used up, she had given it to our colleagues. She asked us to see her husband at a commercial center and said he would give us money. When we got there, we couldn't find him. We were all together. She said her husband was near the commune office. Someone in the group said she was lying. We brought her back to her place. Someone took her out of the car and hit her with a club. Her daughter, who was in the house, was cut with machetes.... There was another place where we went. We wanted to go into the compound, to find the people who were hiding, but there was a Hutu who was protecting the people inside, and he threatened to cut us with a machete. We went back to our vehicle. When we got back onto paved road, we found some soldiers and said there was an accomplice we could not touch. Three soldiers went with guns. They shot the person in front of the door. The soldiers and the civilians went in, but the people who had been hiding had escaped. We found a widow, someone I knew from before. The soldiers asked her for money and wanted to shoot her. I explained that I knew this woman, that she was a widow, that she was not an accomplice, and that she did not have any money. The soldiers left her alone, but when we came back from exile, this woman made me be hit, saying I had been part of that attack.... That day I had not been prepared for what happened. When I returned home, my wife asked me where I had been. I did not respond. I reflected. I saw that what we were doing was not good and that my wife had asked me a question. I reflected and saw that what we were doing was not understandable. I made the decision not to go again. I learned later that a Jehovah's Witness leader was hiding some people. I was alone when I heard this. I went to look for this

man who hid people, and I helped them cross the border. I lived near the border. It was easy for me. The man accepted my help and promised to give me 20,000 FRW per person I helped cross.... Another day, I met some youths who went to attack a family, and they told me there was an accomplice in the family. I went with them, and I found a man I knew. His wife was called an accomplice because he was the cousin of [a senior RPF politician]. I advised the man to give 30,000 FRW to the youths so they would not kill his wife. He said he had already given his money to others, that he only had 10,000 FRW, so he borrowed 5,000 FRW from another Hutu who was at his place. I tried to negotiate with the youths to accept the 15,000 FRW, and they eventually did. I gave 10,000 FRW to the youths, and I said I had to keep 5,000 FRW to share with someone else I was with. They left. I went home.... Later I thought, "Those youths could go back," so I told the man to bring his wife to my house for safety, before taking her across. He agreed, and the next day he went to negotiate with the immigration authorities. The woman crossed. What made me unhappy was that afterward the woman looked for me to kill me, saying I was a killer.... DID YOU KILL? I killed. That same day [the first day, after leaving the house where the soldiers killed the Hutu who was trying to protect Tutsis inside], there was a girl who signaled to us that there was a person hiding in her kitchen. There were two of us. When we arrived, we found a man hiding in the ceiling. We brought him out. He asked for mercy. He said he had money in his house, 100 meters from that place. We went there. We found that the house was already destroyed, nothing remained. He wanted to give us the 5,000 FRW that he had in his pocket. We said it was too little. When we refused, he ran. We yelled. He ran into someone who cut him down. We caught up, and I hit him with my sword. We left him there.... WHY DID YOU HAVE A SWORD? In the morning, there was disorder. There were vehicles going this way and that. SO WHEN YOU LEFT YOUR HOUSE WITH THE SWORD, WAS IT TO GO FIND THE TUTSIS? Yes. HOW DID YOU KNOW THAT THE TUTSIS WERE BEING LOOKED FOR? You saw it, it was said. WHO SAID IT? The radio said the Tutsis had killed our president. WHY DID YOU DECIDE TO GO WITH THE YOUTHS IN THE VEHICLE? We were in the same party, and we had just learned that our head of state, whom we supported, had been killed by the Tutsis. WHAT WAS YOUR ATTITUDE LIKE? We were unhappy. We were serious. DID YOU SING? Some yelled. Others said nothing. When they trapped someone and

were bringing him to the commune office, they yelled, "We caught an accomplice!" WHAT DID PEOPLE CALL WHAT THEY WERE DOING? We said we had to hunt for the accomplices, those *inyenzi* who had killed the head of state, that had to be exterminated [*gutsembasemba*]. "EXTERMINATE" WAS SAID, THEN? Yes. "CLEAN"? No. WHERE DID YOU HEAR "EXTERMINATE"? Even the people in the vehicles said it. Some had Tutsi wives who were not attacked. There were people who were not trusted. Others had Tutsi wives who supported the RPF, and they were attacked. If the husband handed over his wife, he was spared. If not, they were both killed. For example, there was a man who worked at the brewery. They asked for his wife and five children. He said, "Kill me too," and he was killed. WERE YOU THERE? No, but I heard this on the street…. WHAT WAS THE GOAL OF KILLING THE TUTSIS? It was unhappiness, a way to take revenge, to diminish them. AND THEN WHAT? The others who attacked [the RPF] would be weakened. They fought for them. DID THE RADIO ENCOURAGE YOU? We were people convinced the Tutsis would kill us. RTLM [Radio Télévision Libre des Mille Collines, a private radio station associated with Hutu extremists] did not encourage us. On the contrary, it lied, saying we were winning. WHAT WAS THE MOST IMPORTANT REASON WHY YOU PARTICIPATED? I protected my *ubwoko*. People said they would exterminate us. Rwanda's problems are complicated!

———

The following excerpt is from an interview with a Gisenyi man who worked as a farmer, fisherman, and carpenter. Like the preceding interviewee, he was a member of the CDR. Twenty years old and a father of three in 1994, he had completed eight years of primary school and was literate. He had been imprisoned briefly in 1992 after being accused, with a friend, of stealing. Before the genocide, he had Tutsi neighbors, with whom he said he had "no problem," as well as a Tutsi brother-in-law and sister-in-law. He confessed to killing two children, and he received a death sentence.

I went as someone who defends his country that was attacked. I thought that if the enemy came, he would kill me. I went as someone who loves his country, but after having received a command. FROM WHOM? The *conseiller*. WHEN?

April 10. HOW DID THAT HAPPEN? He said that we had to look for the enemy, that the Hutus' enemy was the Tutsis. DID HE COME TO YOUR HOUSE? I lived near the road. He came over. He called. He said we had to defend ourselves and be vigilant. When you have children, you know the youths who are capable. We began patrols. WAS HE ALONE? He was with other *cellule* members, gendarmes, and peasants. The more the war got worse, the more things changed. Later we trained with the army. YOU WENT RIGHT AWAY? Yes, I went with the others. I worked with the others. HOW MANY DAYS DID YOU "WORK"? That continued until we went into exile, and I chose to go into military training when they recruited at the commune. HOW MANY DAYS WERE TUTSIS HUNTED? During the day they were hunted; at night, there were the patrols. There was no peace in the countryside. You could not sleep peacefully.... The country had been attacked, and we had to fight the enemy. When the enemy was finished, there would be peace. WOULD YOU SAY YOU PARTICIPATED VOLUNTARILY? No. It was a law. Whenever a leader gives you a command, you do it. Even now, if someone said, "Look for the enemy," we would do it. We are not above the law. If you disobeyed the authorities, you were killed. Even Hutus. I know of two in my sector. WHY DID YOU CONFESS? Me, personally, it was conscience. When I returned from exile, I was arrested, and I had to confess, and it was a way to ask for pardon from the government in place. If you did not, you were killed.

The interviewee quoted below was from Ruhengeri Prefecture and was a farmer and carpenter when the genocide started. Twenty-seven years old, single, and still living with his parents, the interviewee described his personal situation before the genocide as good. Here he describes why he decided to join an attack. He was sentenced to fourteen years in prison.

I was in an attack, and this attack killed one person. HOW DID YOU FIND YOURSELF IN AN ATTACK? We heard whistles; we went to see; and when we arrived we went with the others. WHY DID YOU GO? When there are whistles, no one stays in the house. WHEN YOU ARRIVED, WHY DID YOU GO WITH THE GROUP? It was necessary, because anyone who did not go with the others was asked for

money. HOW MUCH? More than 5,000 FRW, but if you negotiated, maybe 2,000 FRW or 3,000 FRW. WHY NOT DO THAT? It was not possible. WHY? When you refused, they said you were an accomplice and you hid Tutsis. They could destroy your house, and if you were young you created poverty for your parents. THAT IS HOW YOU FELT? Yes. DID YOU GO WITH A WEAPON? No, we cut tree branches when we went with them. HOW MANY OF YOU WERE THERE? Many…about fifty. Some went this way, others that way. [Name withheld] said, "You go this way, you go that way." HOW WAS THE PERSON WHO WAS KILLED FOUND? A neighbor said she was hiding at a family's house. When we went there, we did not find her. So we searched the banana garden, and we found her hiding under a tree. She gave us money to leave her alone. We refused the money. WHY DID YOU REFUSE? [The leader of the group] said she had to die. WHY? He was with the *responsable,* and he said it as a leader. DID HE SAY WHY SHE HAD TO DIE? Because she was Tutsi…. WERE YOU IN ANY OTHER ATTACKS? No. WHY DID YOU NOT GO IN ANY OTHER ATTACKS? When I was told to go, I refused. EXPLAIN. For the neighboring family, my father was the godfather of the head of the household. My father prevented us from going after that family. When we were called to go, we refused. When we were asked for money, we made the *conseiller* intervene. The *conseiller* recognized that no member of our family should participate in killing this other family. WHY? Our father explained to the *conseiller* that his children could not participate in spilling the blood of his brother.

––––––––

The following excerpt comes from an interview with a former policeman who was a forest guard in one of Rwanda's national parks at the time of the genocide. From Ruhengeri Prefecture, the interviewee was forty-nine years old at the time of genocide, the father of eight children, and comparatively better educated than most Rwandans—he had had several years of secondary education. A staunch supporter of the MRND party, as we shall see, he confessed to killing ten civilians. The interview picks up where he explains the changes that the civil war that began in 1990 caused in his area. He was sentenced to death.

The war ruined relations among Rwandans. The Hutus, the Tutsis, and the Twas had good relations during Habyarimana's regime before 1990. The war killed people, destroyed houses, killed cattle, and ruined the state's infrastructure. HOW DID THE WAR CHANGE RELATIONS AMONG RWANDANS? The Tutsis attacked Rwanda from Uganda, and they killed Hutus. When the negotiations began, they returned and raided the prison here [in Ruhengeri]. They removed the politicians here. Along the way, they killed Hutus—Hutu leaders, *responsables, conseillers,* and if they met a burgomaster they killed him too. When the Hutus saw that their people were finished, they attacked their Tutsi neighbors. HOW DO YOU KNOW THAT *CONSEILLERS* AND *RESPONSABLES* WERE KILLED? We saw them and we buried them…. THERE WERE KILLINGS OF THE BAGOGWE; WHAT HAPPENED? What caused their death was the *inkotanyi* attack…. WHY DID THE *INKOTANYI* ATTACK LEAD TO KILLING BAGOGWE? Because the *inkotanyi* killed Hutus; when Hutus saw their own killed by the *inkotanyi,* they killed the Bagogwe…. WERE YOU THERE? Yes. HOW EXACTLY DID IT START? We went to look for the Bagogwe, and we cut them, and those who had guns shot them. WHY WERE YOU THERE? On January 26, 1991, they found me in a park. We fought with them and killed them. WHO? The Bagogwe. THE BAGOGWE CAME TO THE PARK? Yes. WHY? When the *inkotanyi* opened the prison and killed Hutus, the Hutus began to kill the Bagogwe, and they fled to the park. THEY CAME TO YOUR OFFICE? We were guarding the park, and we found them hiding in the forest. HOW MANY? Nine men; we left the women and children. DID YOU HAVE ORDERS TO KILL THEM? When we found them, we fought them and killed one. We took the others to the office. We filed a report to [a higher official], saying we had trapped some Tutsis. They told us that the *inkotanyi* had attacked Kinigi and terminated people and that we should kill these people. AND YOU DID? Yes…. HOW MANY DID YOU KILL? Two. WAS IT THE FIRST TIME YOU HAD KILLED? Yes. WERE THERE CONSEQUENCES FOR YOU? No. We continued to work until 1994…. WHAT WAS YOUR OPINION OF THE HABYARIMANA GOVERNMENT IN PLACE? Habyarimana was the parent of Rwanda. Habyarimana did nothing bad to Tutsis. He gave work to all the Tutsis who studied. No person in Rwanda thought, "I am Hutu. You are Tutsi." Habyarimana prevented all that. We intermarried. All that was disturbed by the RPF war…. HOW DID THE 1994 MASSACRES BEGIN IN YOUR AREA? I was on duty at night. In the morning, we heard that Habyarimana had been killed.

I immediately went to my commune. I found that the *conseiller* of my sector had sent people to my place because he knew I had a gun. They said, "We must look for all Tutsis," that they were accomplices, and that the *inkotanyi* had killed Habyarimana. These peasants were with the *interahamwe,* who also had guns. I was told that if I did not participate with them, they would kill me too. That is how we killed our neighbors. WHERE DID YOU GO? To the neighbors'. WERE THEY THERE? Yes. HOW MANY? Eight. HOW MANY OF YOU WERE THERE? There were peasants who did not have guns but who said, "Habyarimana is dead. Habyarimana is dead." [ONE THOUSAND?] No. [ONE HUNDRED?] No. About fifty.... ALL EIGHT WERE KILLED? Yes. WITH GUNS? Yes, the *interahamwe* and me. CHILDREN? No. WOMEN? Three. THIS WAS ONE FAMILY? No, this was for the entire sector. YOU LOOKED IN THE HOUSES? We went to the families, and we found them, and we killed them. We went to another family, and we found them, and we killed them. ONE DAY, EIGHT DIED? Yes. WERE THE WOMEN RAPED? No. WHY WERE WOMEN TARGETED? After the death of Habyarimana we killed everyone. WHY? Because of Habyarimana's death. DID PEOPLE STEAL? The peasants looted tobacco and money, and we bought beer. DID YOU DRINK BEFORE KILLING? No. AFTER? Yes. WERE THOSE THE ONLY TUTSIS IN THE SECTOR? No, the others fled; I don't know how they were informed. WHY DID YOU GO WITH THE GROUP? That day was very terrible. If I had not gone, I would have been killed. WHAT DID YOU DO THE NEXT DAY? I returned to the office. HOW WERE THOSE WHO WERE SUPPOSED TO BE KILLED IDENTIFIED? They were neighbors; we knew they were Tutsis. WAS THERE A LIST? No. WHAT DID PEOPLE CALL WHAT THEY WERE DOING? Revenge for Habyarimana. DID YOU THINK THAT YOU WERE WORKING FOR THE NATION? That is where our intelligence comes from. WHAT DO YOU MEAN? We, the peasants, believed that the person who had killed the president was an enemy, that is what we believed. CERTAINLY YOUR NEIGHBORS DID NOT KILL HABYARIMANA. The *inkotanyi,* they were Tutsis; they were Tutsis, so we believed the solution was to kill the Tutsis.... We said we were defending ourselves against the enemy.... All the things that happened in Rwanda were caused by the war between the RPF and the MRND, and the people who are dead and the things that were destroyed, it is the RPF and the government in place that must answer for that.

———

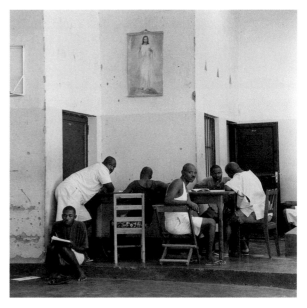

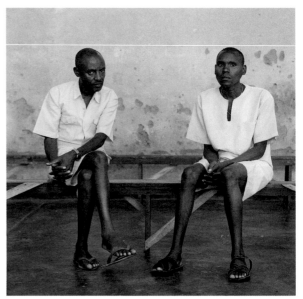

This excerpt is from an interview with a man from Kibuye Prefecture who was sixteen at the time of the genocide. Before the violence started, he received five years of primary education. He was sentenced to seven and a half years in prison.

The plane crashed on April 6, 1994. The people said that since the head of state had just been shot, blood would be spilled in this country. On the seventh, there were no problems among the population. We continued to live together as usual. After the seventh, that is the eighth and ninth, we heard on the radio, "Look for the enemy no matter where he is; he is your neighbor!" After that, the Tutsis fled to the high mountains. After their flight, a war followed that I do not know how to explain. We were together, and then at a certain point, we began to fight each other, without there having been any argument between us. It is a problem! WHAT DATE DID IT BEGIN? After the tenth, that is when people started to kill each other. WHEN YOU HEARD [THE ABOVE PHRASE] DID YOU UNDERSTAND THAT THE TUTSIS WERE THE NEIGHBORS IN QUESTION? What showed it was that the Tutsis left immediately to go to the mountains. YOU DID NOT UNDERSTAND THAT IT WAS THE TUTSIS BEFORE THEY FLED? No. HOW DID YOU COME TO BE INVOLVED IN THESE EVENTS? It is a problem. I began by saying that I do not know how to explain this war. There are problems that befell our country. After the tenth, patrols were established. My father was sick at the time and could not participate in the patrols. He asked me to go to the place where the patrols were done and say I would replace him because he was sick. I stayed. One day—I do not remember the date, but it was in April 1994—there were no roadblocks, but in court it was said that the patrols had roadblocks. That day, a person was taken; she was a Tutsi girl who was going to her older sister's place. The sister had married into a Hutu family, and surely she was going there to hide. WHEN WAS SHE TAKEN? They detected her, but then they let her continue on her way while they followed her to know where she was going. They saw she was going to her older sister's place. I went with those who followed her because I was with them on the patrol. When we arrived, the people we were with asked the wife to bring us the person who had just entered the house. The woman said there was no one in the house. They told the woman, "If you don't bring her, you will die in her place because she too was Tutsi." She still refused, and the people we were with began to hit

her. When she saw that she would be killed, she asked the girl to come out, and she did. [A certain man] hit the girl on the head with an iron bar and killed her. I told you that I was in those killings because I saw those people killing that person. The next day, I returned to the patrol, which means I supported them in their bad actions. Since I had seen that the things done on the patrol were not good, if I had been smart, I would not have returned. I told you, these were problems that befell the country. I say these are difficult problems, because I would say that it was the enemy Satan who moved into people and changed their hearts, and their hearts became like animals. WHAT HAPPENED THE NEXT DAY? There were bad actions, like the day before. WHAT WAS DONE? They took another person. Not in the same circumstances, because it was a person who had fled to his neighbor's house, and the neighbor said, "Since you have come here, we are going together on the patrol." When they got to the patrol, the man explained, "This person came to hide at my place. I did not want to hide him before showing him to you, so you would not suspect me of hiding accomplices and destroy my house." In general, when Tutsis were killed, they were not called *inkotanyi*, they were called accomplices. HOW DID YOU KNOW HE WAS TUTSI? They knew him because he lived in the *cellule*. He was killed immediately. HOW MANY KILLED HIM? Me, me alone. WITH WHAT? A club. I was told, "You, you come on the patrol saying that you are replacing your father who is sick, but we know that you are also Tutsi accomplices." I said we were not Tutsi accomplices. They said, "To prove it, you have to kill this person." I thought if I did not kill him they would kill me because they had just accused our family of being accomplices. WHY WAS YOUR FAMILY SUSPECTED? Because of the Tutsi woman who had married into our family. WHERE DID YOU GET YOUR WEAPON? When I went on the patrol, I had a machete. I was told to kill the person with a machete, and I couldn't. They gave me the club. I DON'T UNDERSTAND HOW SOMEONE CAN KILL SOMEONE HE DOESN'T WANT TO KILL. These are the problems I spoke of before. WERE YOU IN ANY OTHER ATTACKS? No.

———

The following excerpt is from a man from Kibuye Prefecture. The interviewee was thirty-five years old at the time of the genocide; he was the father of one

child. He had had no formal education, could not read or write, and did not belong to any political party. Like many Rwandans, he grew food, but he also earned a small salary working as a waiter in a cabaret. Although he had two Tutsi sisters-in-law, he took an active part in the genocide. He confessed to helping to kill four people and was sentenced to death.

HOW WERE RELATIONS WITH YOUR TUTSI NEIGHBORS BEFORE THE GENOCIDE? Good. We intermarried. We shared everything. WOULD YOU ALLOW YOUR CHILD TO MARRY A TUTSI? When Habyarimana was in power, even I would marry a Tutsi. If I had a child who was old enough to marry and wanted to marry a Tutsi, I would not have prevented it. DID YOUR RELATIONS WITH YOUR TUTSI NEIGHBORS CHANGE WITH THE WAR THAT BEGAN IN 1990? Before the president's death, we had no problems. BACK THEN, DID YOU THINK THAT HUTUS AND TUTSIS WERE DIFFERENT *AMOKO*? Before, we used the name "Tutsi," but there were no misunderstandings, and no one thought about *amoko*. The war changed all that. THE 1994 WAR? Yes. HOW DID THE 1994 MASSACRES BEGIN IN YOUR AREA? The killings reached our sector because of a businessman [name withheld], in collaboration with the burgomaster [name withheld]. They are the ones who created divisions in the population. WHAT DID THEY DO? [The businessman] came and brought people who were like me, but in military uniform. I don't know if they were *interahamwe* or soldiers. When they arrived in the sector, the burgomaster had policemen. With [local] businessmen and the doctors at a hospital, they held a meeting to separate people. They said that the country was being taken over by the Tutsis and that the Hutus were finished. They said that we had to defend ourselves. There were Tutsis who worked in the hospital and a Tutsi pastor. After this meeting, the businessmen and the burgomaster told people to go and hunt these Tutsis. I was not in the meeting, but I went with the others to look for the enemy. WHERE WERE YOU EXACTLY? I was at the cabaret where I worked. They gave us Primus [a brand of Rwandan beer] and said, "You must go look for the enemy." WHAT TIME WAS IT? Around 5 pm on the fourteenth [of April]. DID THEY CALL PEOPLE TOGETHER IN A MEETING OR DID THEY GO DIRECTLY TO THE CABARET? They went to several cabarets. They said to those they encountered in the cabarets, "Come, we are going to look for the enemy." WHO WAS IT EXACTLY? At their meeting, there were a businessman and a doctor, [names

withheld]. YOU WENT WITH THEM? Yes. WHY? Because they led me. WHY NOT REFUSE? I could not. They were authorities. I respected them. If you come and order me, can I refuse? I did not know there would be consequences. WERE YOU GIVEN ORDERS? Yes, and I did not know the consequences. I have confessed for this and I continue to ask for pardon. HOW MANY OF YOU WERE THERE? About four hundred. We went to the hospital and [a technical school]. YOU WENT TO THE HOSPITAL AND WHAT DID YOU DO? We killed forty-three people. DID YOU HAVE A WEAPON? Yes. WHAT? A tool used to remove tires from a wheel. WHERE DID YOU GET IT? It was given to me by the doctor at the hospital. HOW MANY PEOPLE KILLED? Not more than forty-five. WERE YOU AMONG THE FORTY-FIVE? Yes. HOW MANY PEOPLE DID YOU KILL? It was not me alone. If I hit once, others also hit. I hit four. WERE YOU IN ANY OTHER ATTACKS? After that attack, we went to combat the RPF, but the RPF did not come. Instead, we fought peasants from Gitarama. We killed one person, and they killed one of ours. THE PEOPLE YOU FOUGHT WITH WERE HUTUS? In Gitarama, the Hutus were united with the Tutsis to fight us. We won. AND THEN YOU ENTERED GITARAMA? Yes. WHAT HAPPENED? We killed one person, and they fled. DID YOU ENTER GITARAMA TO LOOK FOR THE TUTSIS? We fought each other 3 kilometers from the river. When they fled, we returned to Kibuye. AND THE NEXT DAY? We did patrols. We began the patrols after the deaths of the people at the hospital…. WHAT DID PEOPLE CALL WHAT THEY WERE DOING? We said we were on an attack (*igitero*), but today the government says "exterminate" (*gutsembasemba*). We thought it was a war. We called it war…. After the death of our president, since we thought there were soldiers, we thought we could win the war and the authorities would install another president after winning the war. DID YOU TAKE ANYTHING DURING THE GENOCIDE? Yes. WHAT? Money, but not from houses, from the pockets of those I killed. HOW MUCH? They were Belgian francs. I had seven bills marked 1,000 and six of 500. I had thirteen bills…. YOU TOLD ME THAT BEFORE, YOU HAD GOOD RELATIONS WITH THE TUTSIS. HOW COULD YOU THEN GO KILL TUTSIS? It was not my will. It was because of the authorities who asked me to do it. If you are my authority and you tell me to kill this Hutu [points to my assistant], I could kill him even if I had no disagreement with him. TRULY? If you rule me, if you are my leader, and you tell me to do it, I could do it. It was not only the Tutsis. If he was Hutu, I could do the same thing. Before these things happened, I never killed anyone. BUT

SURELY YOU KNEW THAT KILLING WAS WRONG? I saw that it was wrong. If I am pardoned, I will not do it again. WHY DID YOU ACCEPT ORDERS FROM A LEADER IF YOU KNEW IT WAS WRONG? I accepted the orders of those leaders because the RPF had just killed the head of state. We were asked to fight for our country. WHAT DID YOU THINK WAS THE PURPOSE OF THESE KILLINGS? When someone commits a crime for the first time, he believes there will be some benefit in the future. At the time, I did not think there would be consequences. I thought we were fighting for the country in order to be comfortable in our country. That is why I accepted these orders. HOW DID PEOPLE EXPLAIN TO THEMSELVES KILLING WOMEN AND CHILDREN? We obeyed the orders they gave us. We were told that if you killed the father and the woman and left the child, there would be consequences. The child would grow up and ask you about his father or mother; the wife would ask about her husband. WERE THE WOMEN RAPED? No. WHY WERE CIVILIANS CONSIDERED ENEMIES? Because they would inform the others about who had committed the crime.… I did not fight to be a leader or to be employed in a hospital. I did not know how to read or write. I went because of the leaders who ordered me.… You must ask for pardon for me, because I will not do another crime. You must ask the head of state to give up on vengeance, to leave us in security, as Habyarimana did. We don't hate him. We must live in peace. We must avoid killings, because we regret them.

———

The following excerpt is from an interview with a farmer, also from Kibuye. He was thirty-three at the time of the genocide and had five children. He was illiterate, never having received any formal education. He did not belong to a political party, nor did he have any Tutsi family members (although he described good relations with his Tutsi neighbors). He confessed to killing two people, and he was found guilty of leading an attack, for which he received a life sentence.

These killings were begun by the *inkotanyi* after they had killed the head of state. WHAT HAPPENED IN YOUR AREA? We joined the Tutsis and fought off people from other regions that had attacked our area. WHEN? Four days after the death of the president. WHAT TIME? Early in the morning. WHAT

HAPPENED? When they came, we pushed them back. After the attack, the Tutsis fled to Bisesero [hills in Kibuye Prefecture]. WHY? Bisesero is a very large place where they could hide. WHY DID THEY FLEE YOUR SECTOR? They thought they would eventually be killed if they stayed in this small sector. WHY DID YOU JOIN THEM TO FIGHT IN THE ATTACKS? We were together, sharing life and death. YOU WERE NOT ANGERED BY THE DEATH OF THE PRESIDENT? People became angry later, because of the attacks from other regions. They said that the Tutsis had killed the head of state. HOW DID YOU BECOME INVOLVED IN THE KILLINGS? I went because of the people who came from other regions, who said that the Tutsis had just killed our parent. They had to be killed. EXPLAIN WHAT YOU MEAN. We lived together for a long time, under the government of Habyarimana. We killed them because the RPF had begun the war. THE OTHERS CAME, AND WHERE DID THEY FIND YOU? At a center called [name withheld]. There was a cabaret. WHAT WERE YOU DOING? Drinking banana beer. HOW MANY DAYS AFTER THE FIRST BATTLE WAS THIS? Four or five. WHAT DID THEY SAY? They said, "Elsewhere we have finished killing the Tutsis; why are you still with them?" AND THEN? The Tutsis who had not fled were killed. DID YOU JOIN THE ATTACKERS? No, but there was a child they had wounded. The uncle of this child came to see me at the cabaret. He told me, "There is a child who has been badly wounded. Come, help me bury him." I went with the uncle. We found the child. His neck and legs had been cut. His uncle finished him by hitting him with a club. WERE YOU EVER IN AN ATTACK? Yes, I went. WHEN? The next day. WHAT HAPPENED? We left that same cabaret. We were with people at the cabaret, and others joined us. That attack killed three people. They are the ones for whose deaths we are accused. WHAT CHANGED FOR YOU? YOU SAID THAT BEFORE YOU HAD GOOD RELATIONS WITH TUTSIS. YOU WENT TO FIGHT THE ATTACK. What changed was the death of Habyarimana. BUT AFTER HIS DEATH YOU WENT TO FIGHT ANOTHER ATTACK. When the attacks came back, they said, "The Tutsis are bad. They killed the president." And that is when we killed them…. WHY WERE THE THREE KILLED IN THE ATTACK? Because they had killed the head of state. WERE THEY WOMEN AND CHILDREN? Children. One was young. Two others were about twelve. SURELY IT WAS NOT THEY WHO HAD KILLED THE HEAD OF STATE? After the death of the head of state, people said the Tutsis were mean. I DON'T UNDERSTAND. YOU SAY YOU HAD GOOD RELATIONS WITH YOUR TUTSI NEIGHBORS. YOU JOINED THEM TO

FIGHT OFF THE ATTACK. SOMEONE COMES AND SAYS, "THE TUTSI ARE BAD; THEY MUST BE KILLED." AND YOU GO OUT AND KILL THEM? Yes. I DON'T UNDERSTAND. What can I say to make you understand? HOW DID YOU IDENTIFY THE PEOPLE WHO WERE SUPPOSED TO BE KILLED? In our *cellule*, we knew where those people were. WAS THERE A LIST? No. WHAT DID PEOPLE CALL WHAT THEY WERE DOING? Killing the enemy. IN YOUR OPINION, WAS YOUR PARTICIPATION VOLUNTARY? Yes; no one pushed me to do it. WHAT WAS THE GOAL OF THESE KILLINGS? There was no goal. The *inkotanyi* made these things happen. The *inkotanyi* went into the peace negotiations with the president. Instead of accepting, they killed him; that is why these things happened. BUT HOW CAN YOU EXPLAIN TO YOURSELF KILLING WOMEN AND CHILDREN? It was anger. IF A SOLDIER KILLED SOMEONE HUNDREDS OF KILOMETERS AWAY, I WOULD NOT GO OUT AND KILL MY NEIGHBOR'S CHILD. It was necessary because of anger.

––––––––

This excerpt is from an interview with a fisherman and farmer from Cyangugu Prefecture in the southwest. At the time of the genocide, he was thirty-four years old; he is a father of three and illiterate. He confessed to killing three people and to participating in a group that killed many more. He was sentenced to life in prison.

We spent the night out on patrol. It was in 1994. I cannot tell you the date because I cannot lie. When dawn came, there were raindrops. The leaders came, those who led us on the patrol. They woke us up; they told us to take our weapons and get up quickly. They went to all the houses where there were men. I could not refuse to get up. They told us that Habyarimana's plane had been shot down, that we had to find a way to defend ourselves, and that the Tutsis had killed him. That is when we understood that the Tutsis were the enemy. They told us, "Find a way to defend yourself. You are with the enemy." We became angry because they told us that everywhere the *inkotanyi* went they killed Hutus. They counted us, we who had obeyed, and found that there were not many of us. They told us, "There is no problem. Work. Others will come later. Our head of state just died; these people cannot abandon us." They told us that in Byumba, everywhere the *inkotanyi* went, they cut pockets in bodies and told people to put their hands inside the pockets. It is true. If a

Tutsi succeeds in trapping you, he kills you in this way. We began to kill the Tutsis because our parent [the president] had been killed. As for those who refused to kill, we thought that we would punish them afterward because they had not helped us to combat the enemy. HOW MANY OF YOU WERE THERE? Many. They counted twenty, and that is where we began to kill people, because there were Tutsis with us on the patrol. When they woke us up, they did not separate us. They woke up every man. HOW MANY TUTSIS WERE THERE? Three. HOW MANY AMONG THE SEVENTEEN OTHERS KILLED THEM? We did it together. There were about nine of us. Then we looked for others. HOW WERE THE HOUSES IDENTIFIED? They were neighbors. We knew them. We knew that at such and such a place, there was a Tutsi. WERE THERE LISTS? I was not with the group that had the lists. WHO HAD THE LISTS? The *conseillers* and the *responsables,* and the burgomaster too, it seems he knew too. HOW MANY WERE ATTACKED THAT DAY? All the houses where there were Tutsis in the sector. The second day no one worked. WERE HOUSES BURNED DOWN, OR WERE PEOPLE KILLED? We killed people. Some were killed at the sector office where they had been collected. The second day, we destroyed houses, because there were no more people to kill. THE FIRST DAY, YOU WENT TO SUCH AND SUCH A HOUSE, AND WHAT DID YOU DO? When we found the head of household, we killed him. When we did not find him, we continued on our way. The next day I could also have gone to destroy houses, but I was afraid of the people I had killed. THE WOMEN AND CHILDREN WERE SPARED? Today they are living. WHAT DO YOU MEAN YOU WERE AFRAID OF THOSE YOU KILLED? IF THEY WERE DEAD, WHY DID YOU FEAR THEM? Because my wife told me, "There will be consequences for you because of the things you did." My parents repeated it too. That is why I was afraid and why I did not go loot the second day. And it is true. You see I have consequences—two children and their mother were shot to death when we were running [in Zaire]. Even today when I sleep, I recall all that. THE KILLINGS YOU DID? What I did. THE GROUP THE FIRST DAY STAYED AT TWENTY? It grew a lot, but you will excuse me because I don't remember exactly how many. ABOUT A HUNDRED? Many. I cannot know. They came from all sides, with many attacks here and there. IF PEOPLE FOUND A HUTU WHO DID NOT PARTICIPATE, WHAT DID THEY DO? They said the Hutus who did not want to help us even though the parent was dead would be

punished later. WHAT IF SOMEONE REFUSED? Everywhere I went, no one refused. People were angry because the parent was dead. People ran all over to save the country.... After killing the three [on the first morning], we were divided into subgroups. Some went here, others there. Where we went, there were three of us. We left our *cellule*. We arrived at [name withheld]'s place, a Tutsi. I told my colleagues, "Let's go kill him," and I did. YOU LEFT THE WOMEN AND CHILDREN? I killed [name withheld], his son, and his grandchild. A CHILD? He was three or four years old. WHAT ABOUT THE WOMEN AND THE GIRLS? I left them. YOU KILLED THEM ALONE? Yes, it was I. YOU CONTINUED ON? I took a goat. But later [name withheld] took it, saying that all the people who killed people would bring things they had looted. AND THEN? I went home. WHY DID YOU GO TO THAT HOUSE? I was confused. I had just seen the three that had been killed, and I added three others. My head no longer functioned very well. I had to return to the house. DID SOMEONE DIRECT YOU TO THE HOUSE [OF THE TUTSIS WHO WERE KILLED]? No. WHY DID YOU CHOOSE THAT HOUSE? Because I knew him, and we were told that we had to remember all the houses where there were Tutsis. YOU SAID THAT BEFORE YOU HAD GOOD RELATIONS WITH THE TUTSIS. HOW COULD YOU TAKE A MACHETE AND SUD-DENLY GO KILL THEM? It is because of bad leaders who told us to do these things. If I had killed someone and they had arrested me, there would not have been these killings. If you hit a child when he makes a mistake, he does not repeat the mistake. SAY MORE ABOUT THE FOUR WHO COLLECTED PEOPLE THE MORNING AFTER THE PATROL. They said they had been sent by the admin-istration, and we trusted them. We asked the *responsable* of the *cellule*, "Do you accept that these things will be done?" and he said, "The enemy must be fought." DID THEY SAY WHO EXACTLY IN THE ADMINISTRATION SAID THIS? No, they only said that the enemy, the Tutsi, had to be gotten rid of.

The following excerpt is from an interview with a Cyangugu man who was twenty-four years old at the time of the genocide. A father of one and a farmer, the interviewee had completed his primary education. He belonged to the MDR opposition party, and he had two Tutsi relatives—a sister-in-law and an

aunt. He confessed to killing three people and was sentenced to eleven years in prison.

In 1994, at our place, when Habyarimana died, the Tutsis who lived in our *cellule* and our sector fled to a church. Others fled to the communal office. Others were killed where they were in the countryside. Some fled to Zaire. Others are here. At our place, in general, I would say that the leaders of the parties were important. At their meetings, they introduced divisions, saying the PL was for the Tutsis, the MDR was for the Hutus, and the CDR was for pure Hutus. These people taught us that we had to kill the *ubwoko* because Habyarimana had done things for their benefit. WHEN DID THE KILLINGS BEGIN? The eighteenth. That is when the Tutsis at the church were killed. Those at the communal office were killed on the nineteenth, the next day. YOU WERE THERE? I was at the church…. At the time, I had just gotten married, and I did not yet have ideas that could persuade others. It was necessary that I go with those people, who had their own interests. DID SOMEONE COME TO YOUR PLACE? They came to see me at my house. WHEN? The seventeenth, because we attacked on the eighteenth. BEFORE THAT, WERE YOU IN ANY ATTACKS? There had been an attack because before attacking [the church of] Nkanka, there was the death of a man from our place, [name withheld], and that is when the killings began. WHEN? The ninth. WERE YOU THERE? Yes. DESCRIBE WHAT HAPPENED. The people in our area and the people who were his friends and had money said that he was an intimate friend of the RPF and that he brought contributions to the RPF. But they hated him, and they had him killed because they knew there would be no consequences. After his death, that is when the Tutsis of neighboring *cellules* fled to the church and the commune office. HOW DID YOU FIND YOURSELF IN THE ATTACK? At our place, there is a center called [name withheld]. We were used to meeting at this center. People of all categories were there. There is where it was said that [this person] was an intimate friend of the RPF. WHY DID YOU GO TO THE CEN-TER? You drank beer there, and the meeting was done in my presence. DID YOU GO THERE TO HAVE A BEER? Yes. DID YOU HAVE A WEAPON? No. WHO LED THIS MEETING? The *conseiller*. HOW MANY PEOPLE ATTACKED HIM? Over twenty. SOLDIERS? No. *INTERAHAMWE*? No. There were no *interahamwe* in our area. HOW MANY KILLED HIM? Others were also killed there. HOW MANY?

Three in total. HOW MANY KILLED THE THREE? Three. YOU? I tied them. WERE YOU ORDERED TO TIE THEM? A person is not a cow. These are things that are difficult to explain. You see, to take someone who sees a machete, who sees a sword, and to kill him just like that, it is difficult. It was necessary to tie them before killing them. WAS IT YOUR IDEA? I could not have this idea. I had no problems with them. SOMEONE ORDERED YOU? Yes, our bad leaders. THE CON-SEILLER? Yes, with the party leaders. WHICH PARTIES? The *conseiller* was in the MRND; the leader of the MDR and the JDR [Jeunesse démocratique républicaine, the MDR youth wing] from our sector were also there. WHO CAME TO YOUR PLACE ON THE SEVENTEENTH? I cannot say. WAS IT EVENING OR MORNING? The evening, we met at the market. They made us understand that since Habyarimana had been killed by the Tutsis, it was a reason to kill them too. DID SOMEONE COME TO LOOK FOR YOU SPECIFICALLY? The market was ten minutes from my place. HOW MANY OF YOU WERE THERE? About fifteen. WHAT WAS SAID? The house of the person who had been killed had been destroyed. That is where all the youths met; that is where we met to attack the parish. We called ourselves the "cardinal" group [a reference to the planned attack on the church].... WHY DID YOU DECIDE TO ATTACK THE CHURCH? To attack the Tutsi enemy. WAS THE ATTACK PLANNED? That is what we did. WHO ORGANIZED THE STRATEGY? Those who were accustomed to the war. YOU MET THE NEXT DAY? Yes. WHAT TIME? 7 am. WHERE? A place where the road went directly to the church. DID YOU HAVE A WEAPON? A machete. HOW MANY OF YOU WERE THERE? Many. There were people came from a neighboring commune because Tutsis from there had fled to the church. WAS THE ATTACK COORDINATED WITH THEM? No, before the attack, traditional whistles were used in the morning. When we arrived at the church, all the sectors were there. Then there were about eight hundred of us. We killed everyone there. Those who survived fled to the commune office. The next morning, we found them there. Some were killed then. Others fled to the stadium. HOW WAS THE ATTACK ON THE CHURCH DONE? There were police who guarded the people. When we arrived, the police fired shots, but they did not hit anyone. The police were put there by the state. Since the attackers were also from the state, the police protecting the Tutsis did not shoot directly at the attackers. They shot in the air. AND THEN? The attackers were not afraid, because the police did not kill anyone. They advanced and killed people. WITH GUNS?

They used grenades, machetes, swords, and clubs. WHOM DID THE GRENADES BELONG TO? The people from [the neighboring commune]; they were former soldiers. WHO LED THE ATTACK? [Name withheld]; he was the leader of the JDR at the sector level.... WHY DID YOU GO? I went because I was the youngest of our group. When they met to decide to go kill, my ideas could not change those people. WHY DID YOU GO TO THE MEETINGS? I had to respect the law of those who were higher than me. WHY? Rwandans obey the authorities. DID PEOPLE OBLIGE OTHER PEOPLE TO PARTICIPATE IN THE ATTACK? No.... WHAT DID PEOPLE CALL WHAT THEY WERE DOING? Killing the enemies. DID PEOPLE SING? No.... After Habyarimana's death, our national leaders made it understood that the enemy was none other than the Tutsis, because the RPF opposed the government in place. It was made clear that the RPF wanted the Tutsis to be in power. It was necessary that the people for whom the RPF was fighting be killed. HOW WAS THIS MESSAGE TRANSMITTED? The radio, RTLM, which said that our enemies were not far, they were even in our banana gardens. DID YOU THINK YOU WERE WORKING FOR THE NATION? When you have not yet committed a crime, you have no problem. But afterward, you become troubled. You cannot have peace in yourself after you have killed someone.... WHY DID YOU CONFESS? After those killings, I fled. Then the war came to Zaire; I saw how some refugees died because of hunger; others drowned in the river. When I saw that I had returned without having died and when I was imprisoned, I felt I had to confess, and I accepted the crime.

PHOTOGRAPHS

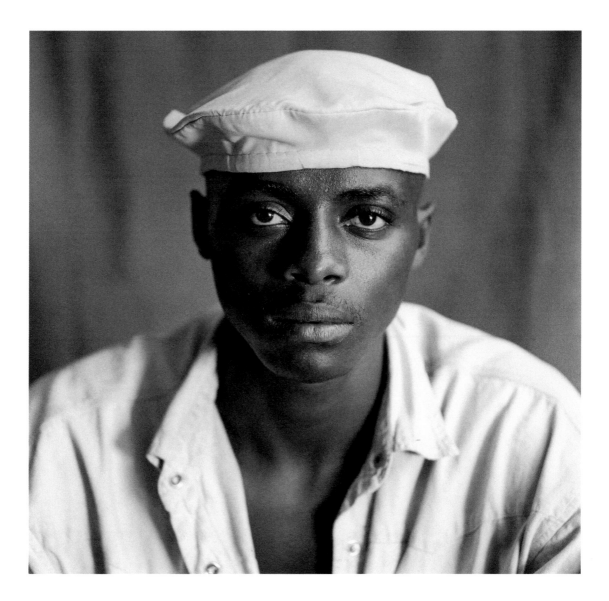

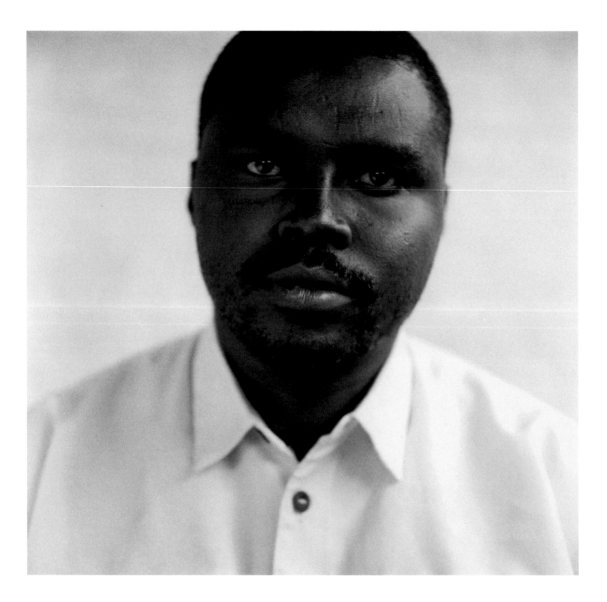

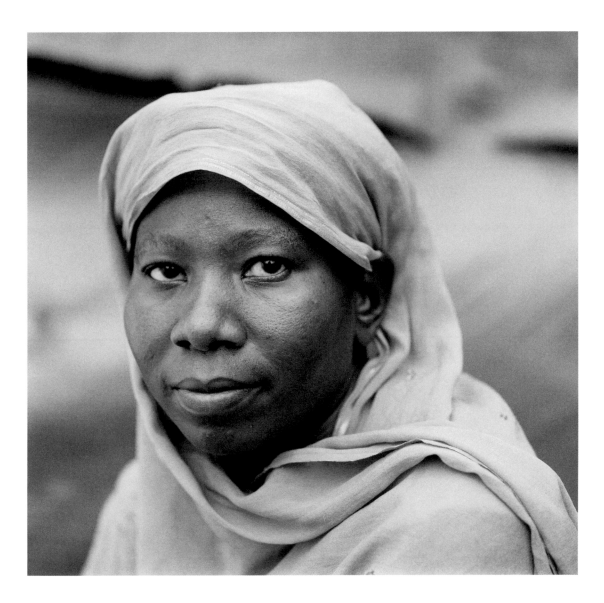

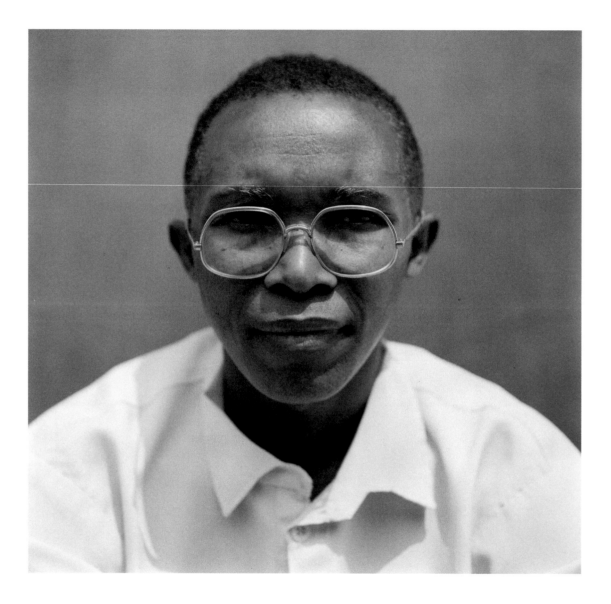

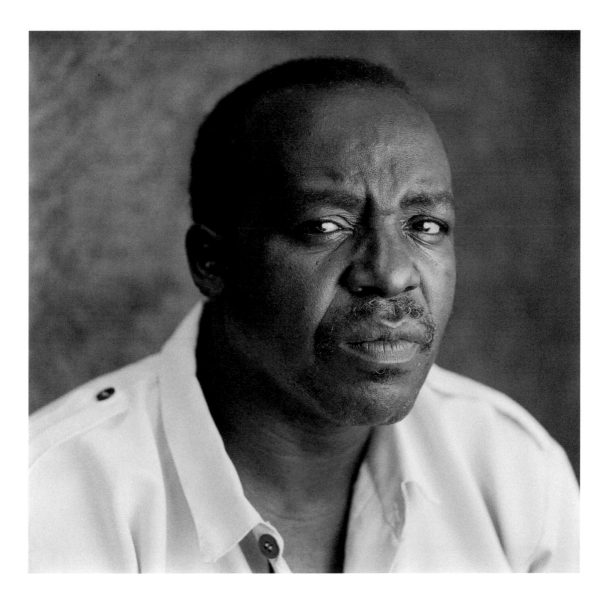

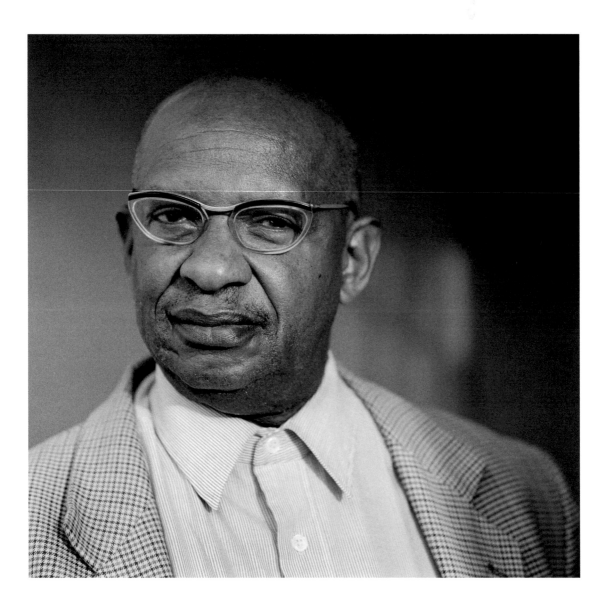

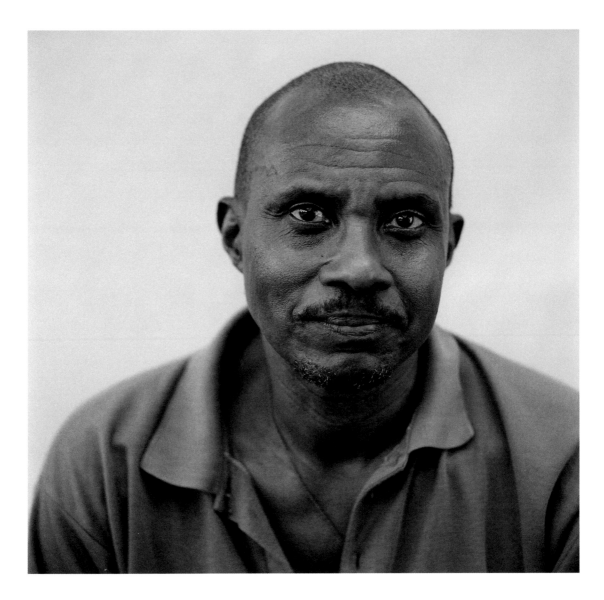

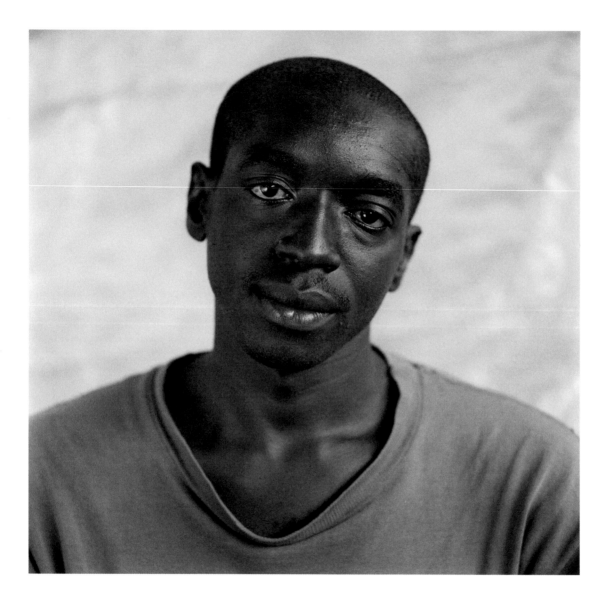

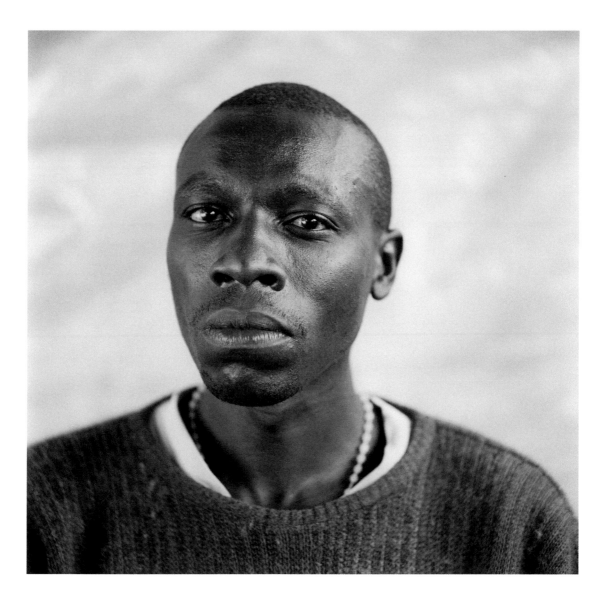

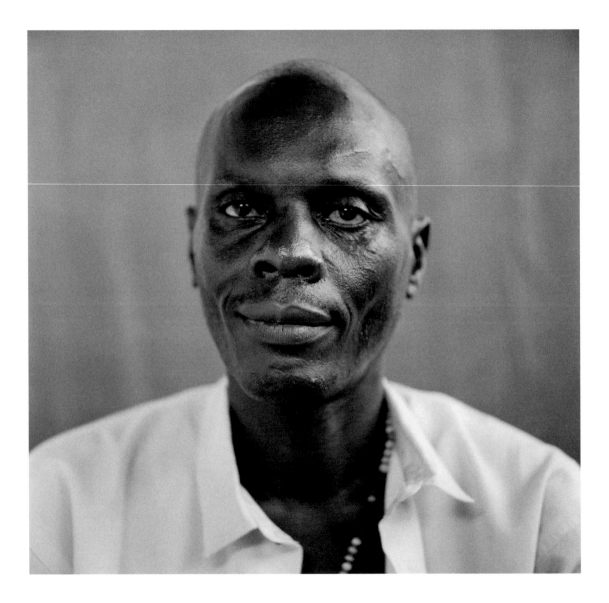

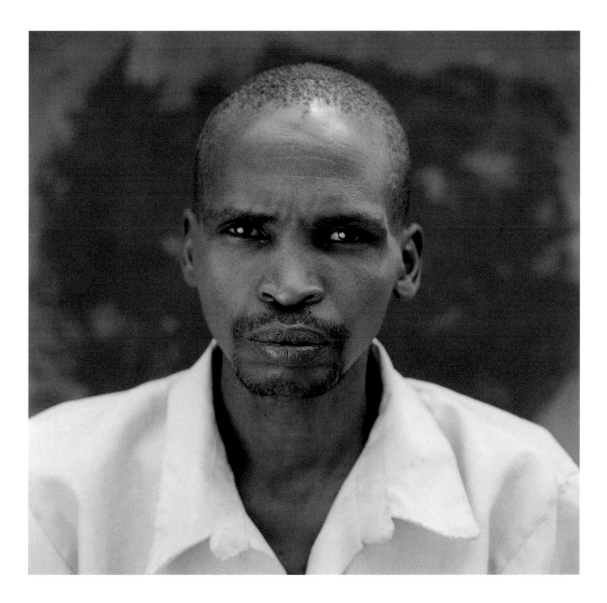

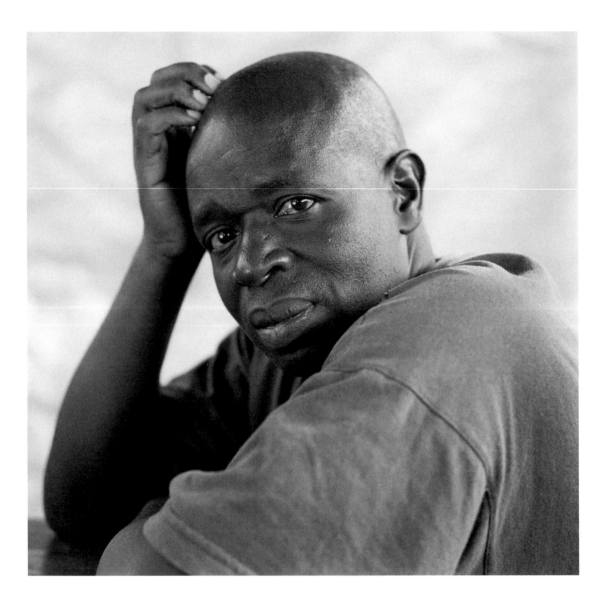

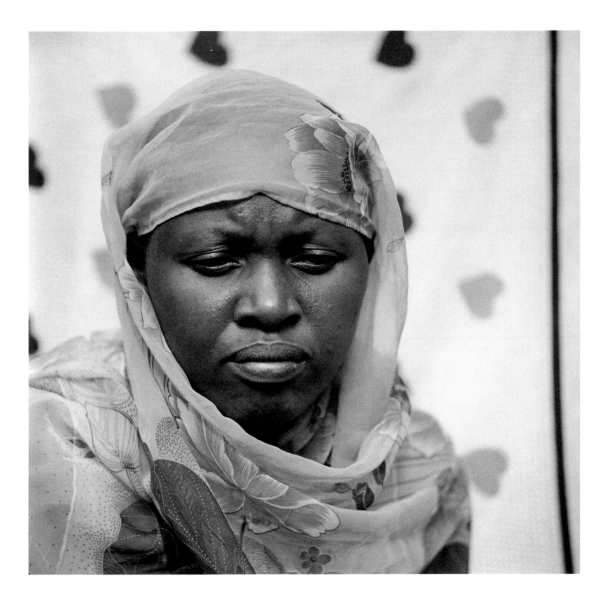

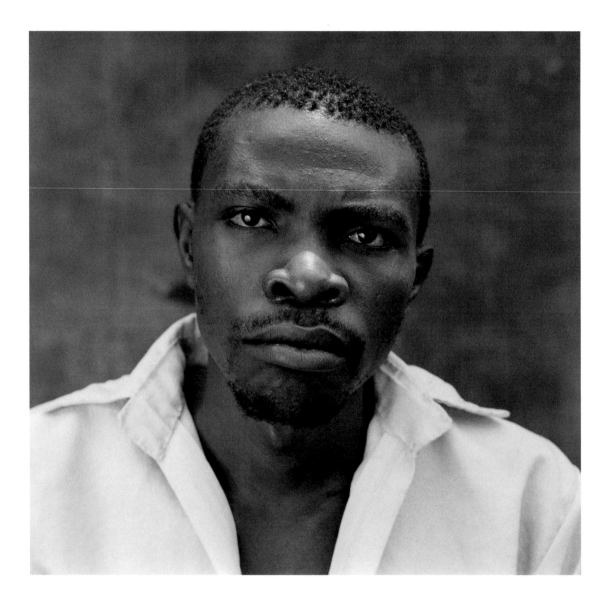

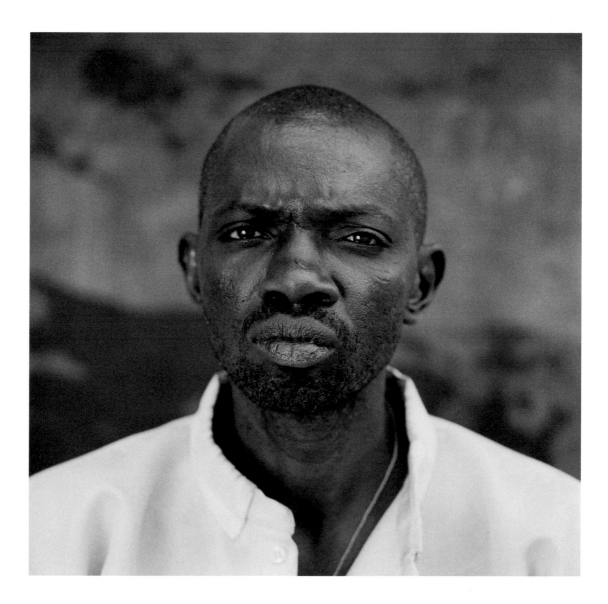

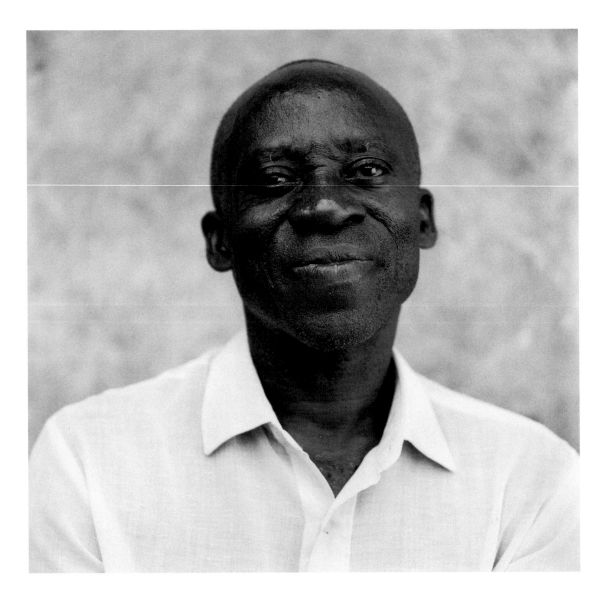

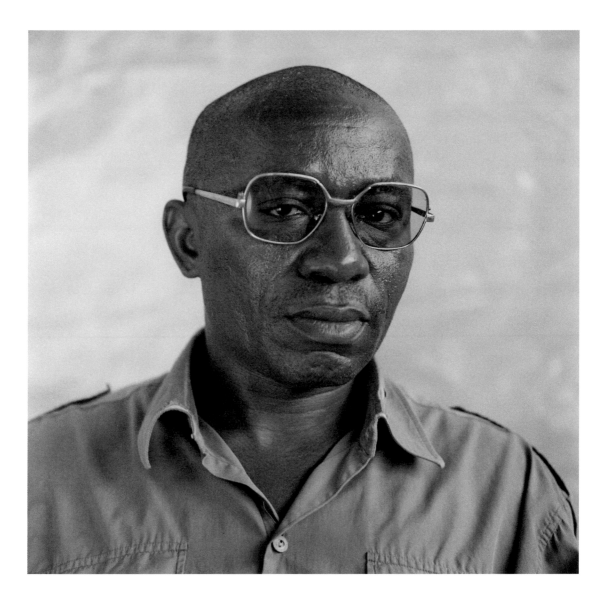

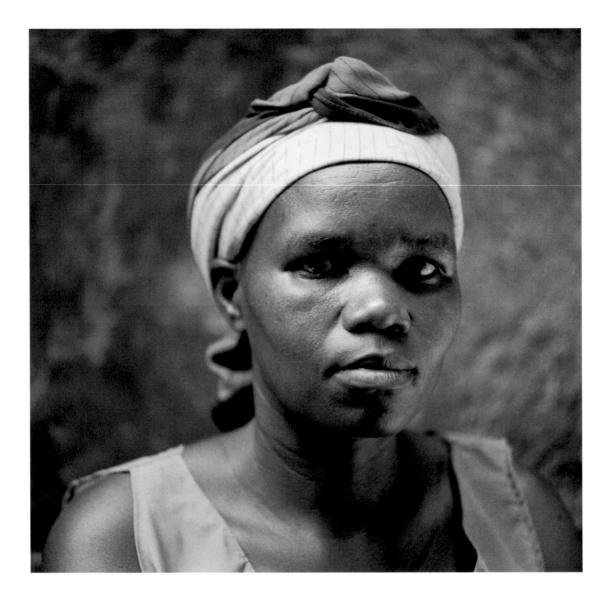

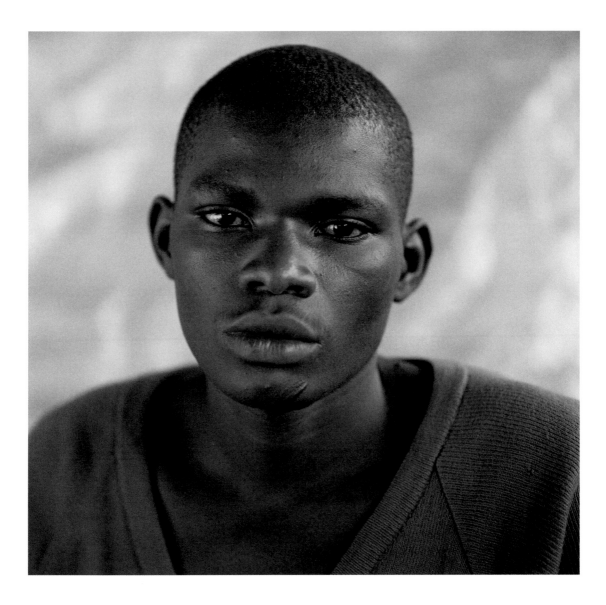

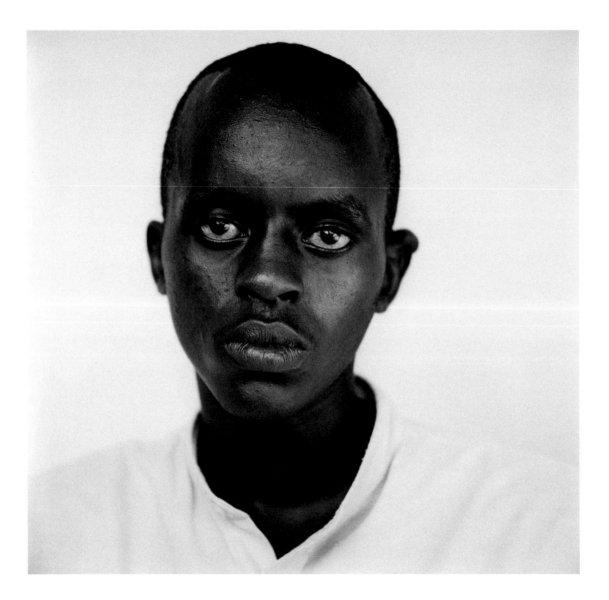

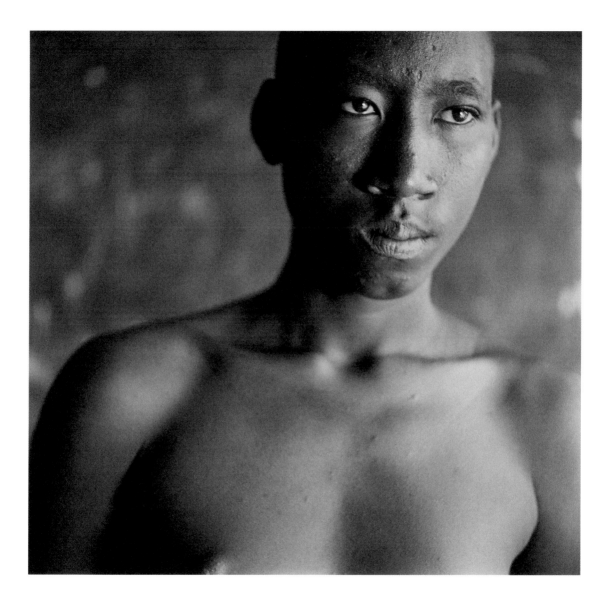

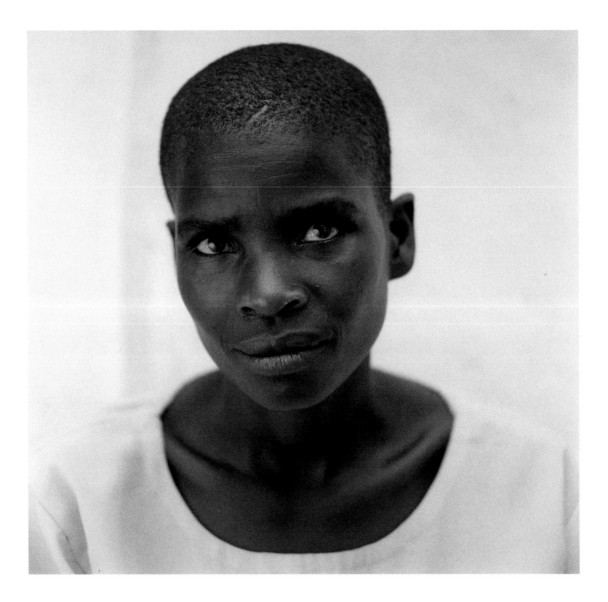

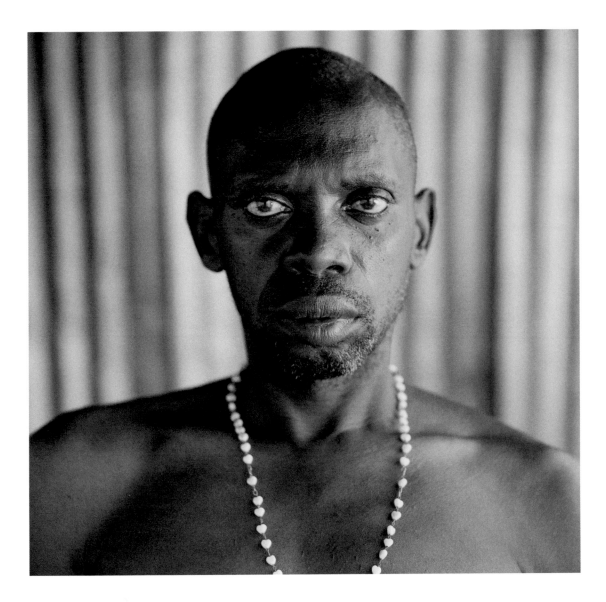

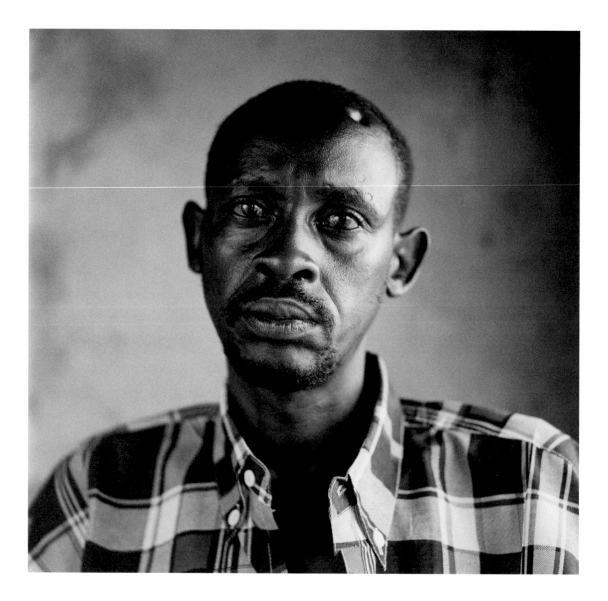

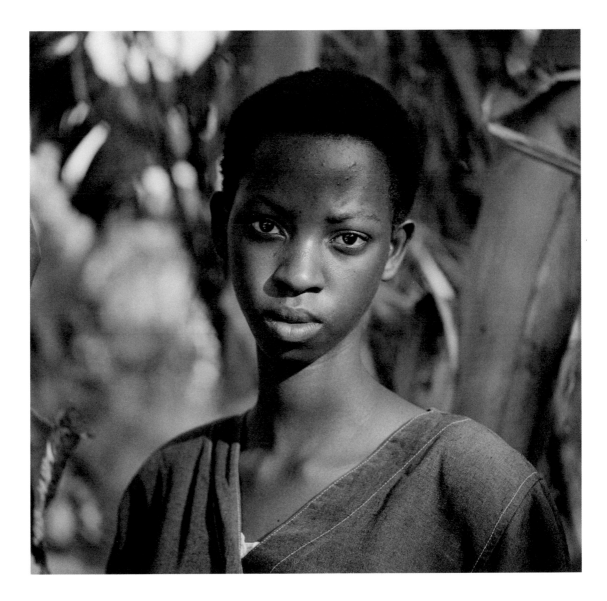

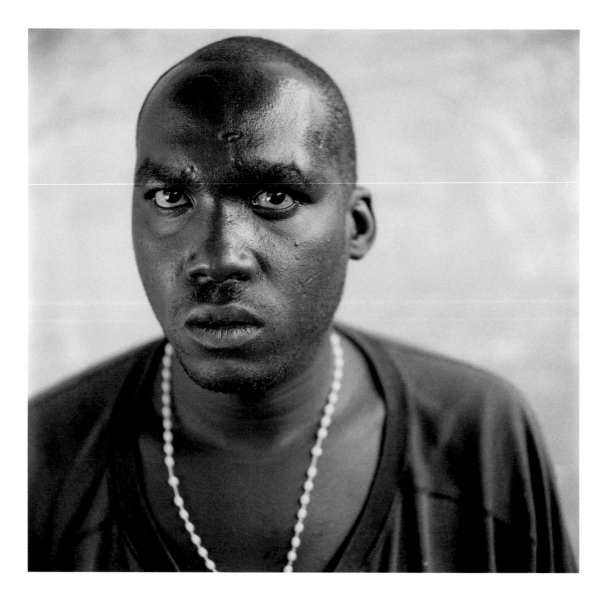

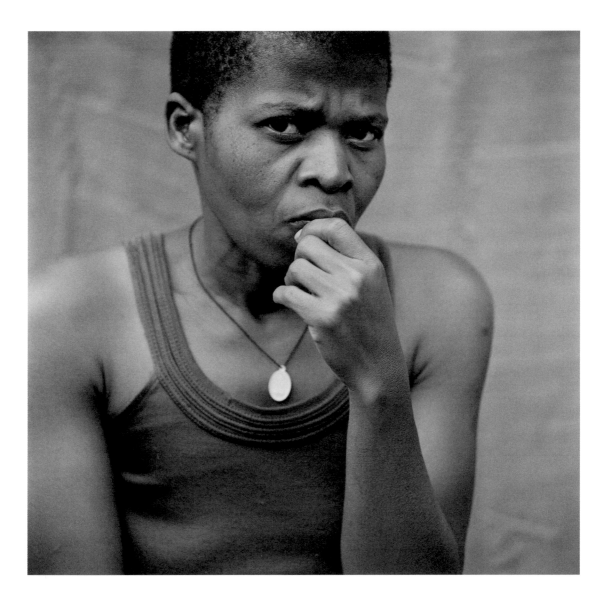

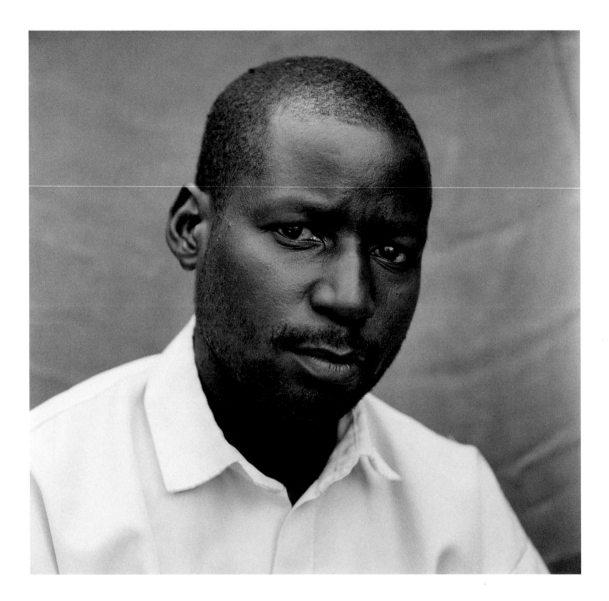

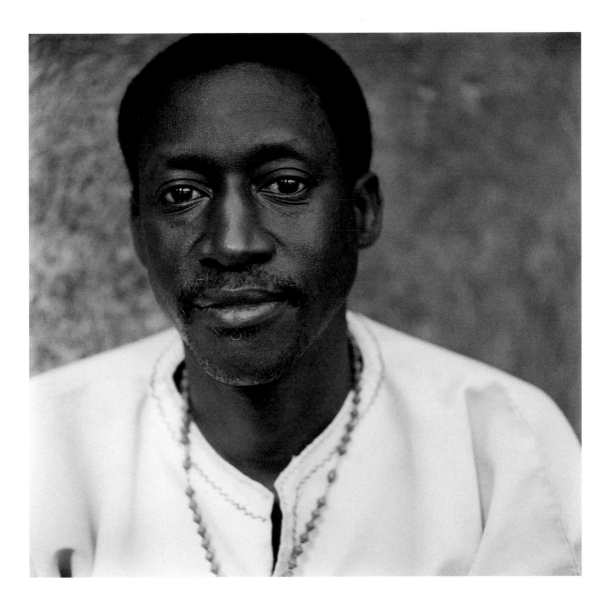

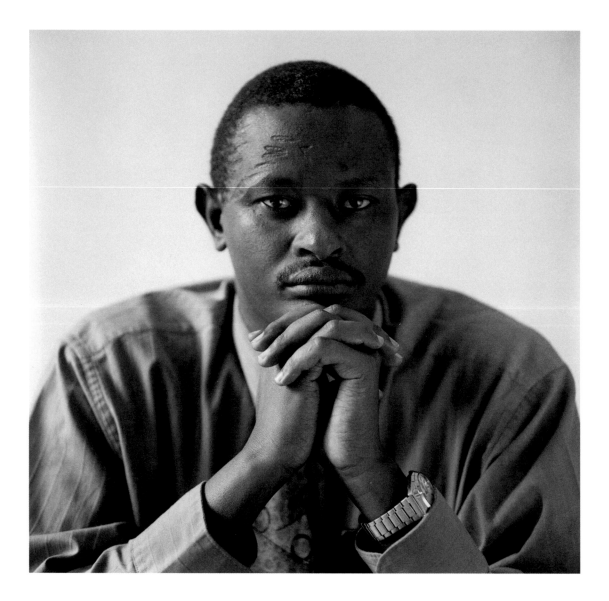

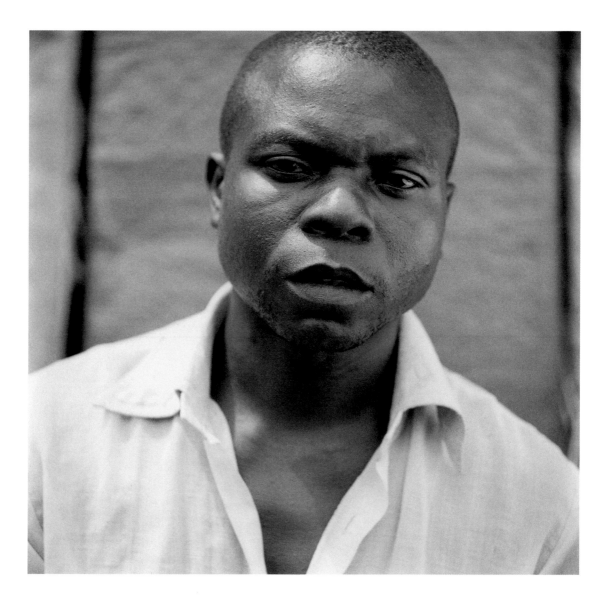

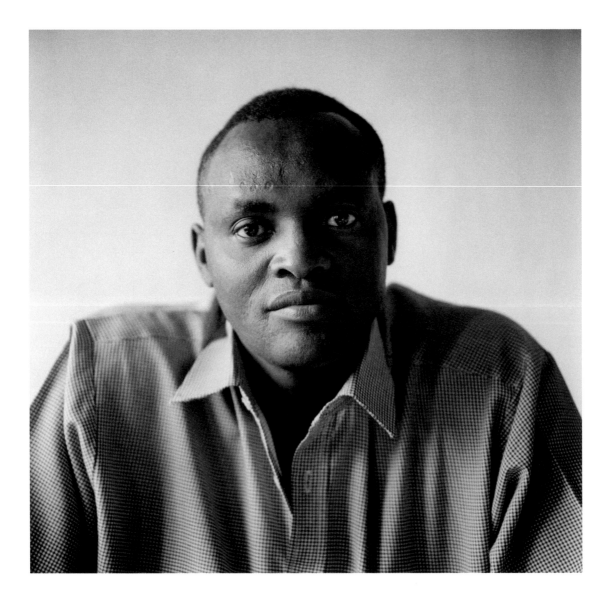

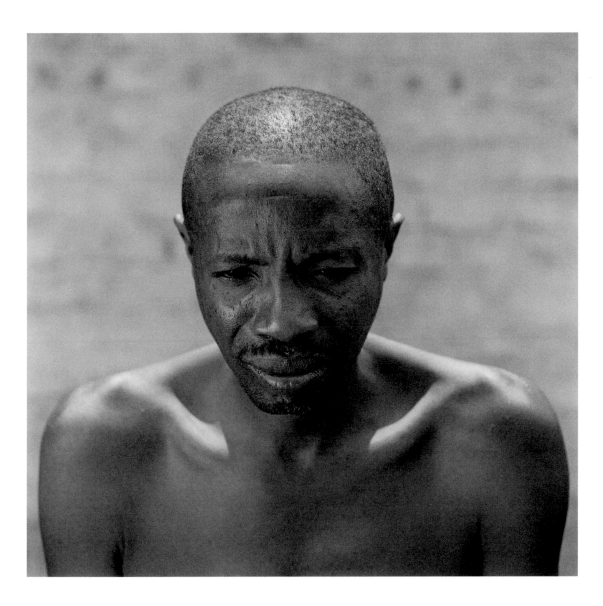

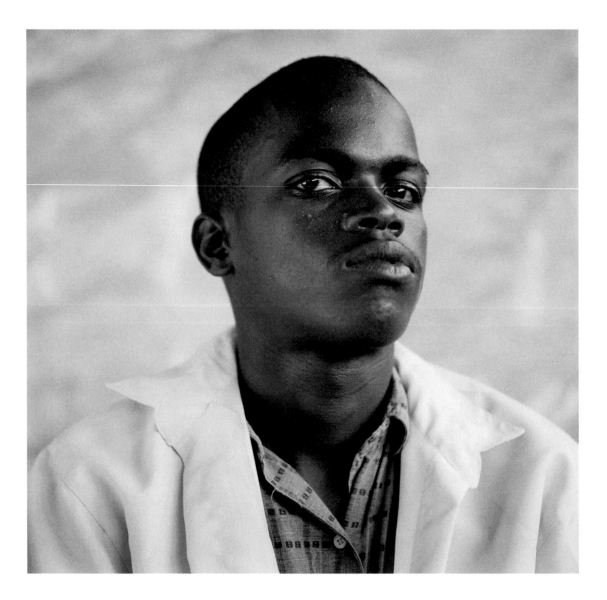

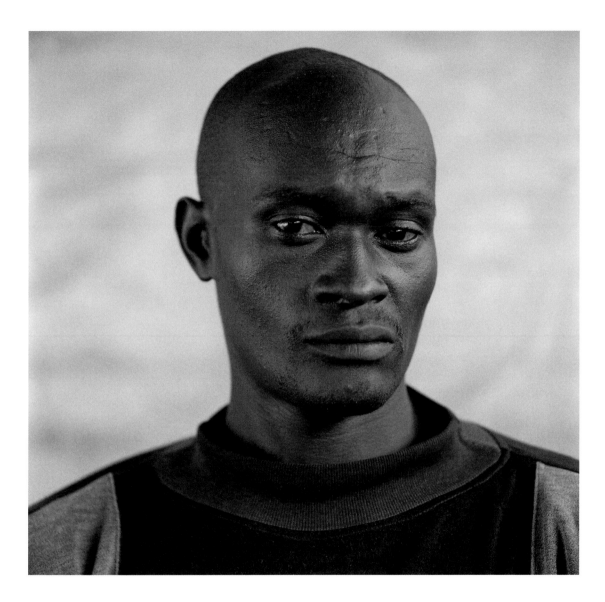

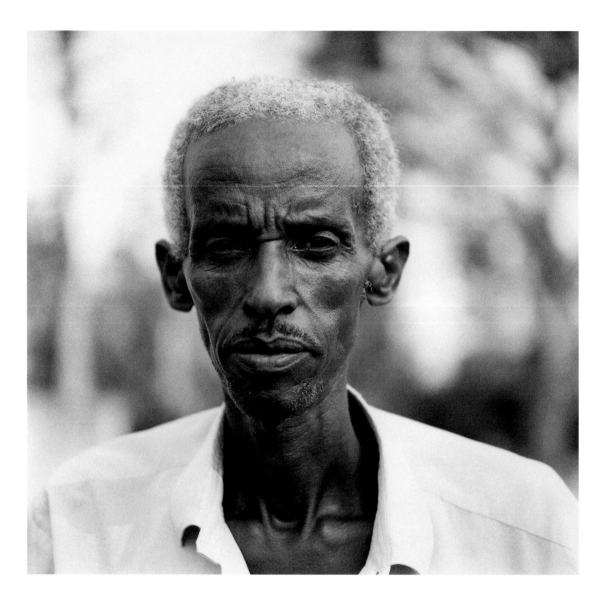

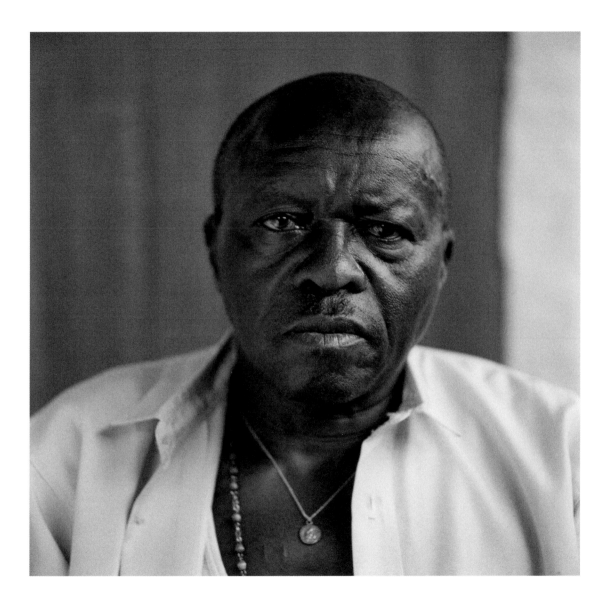

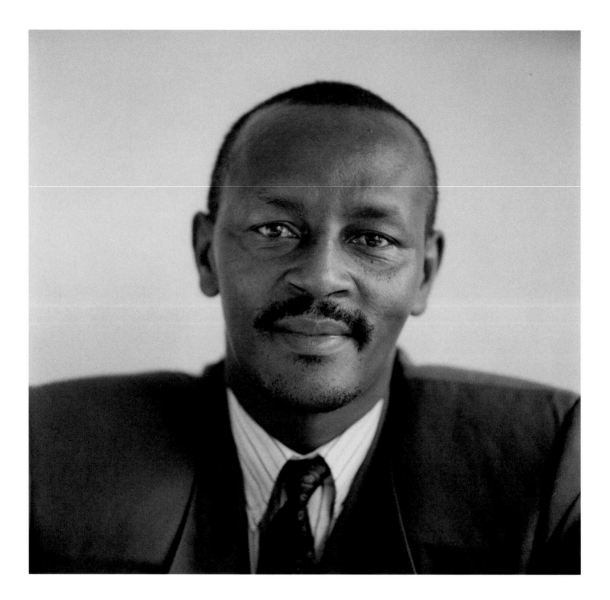

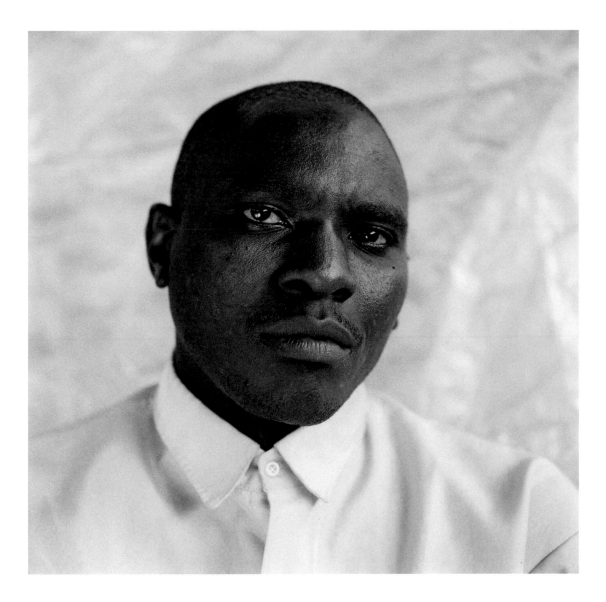

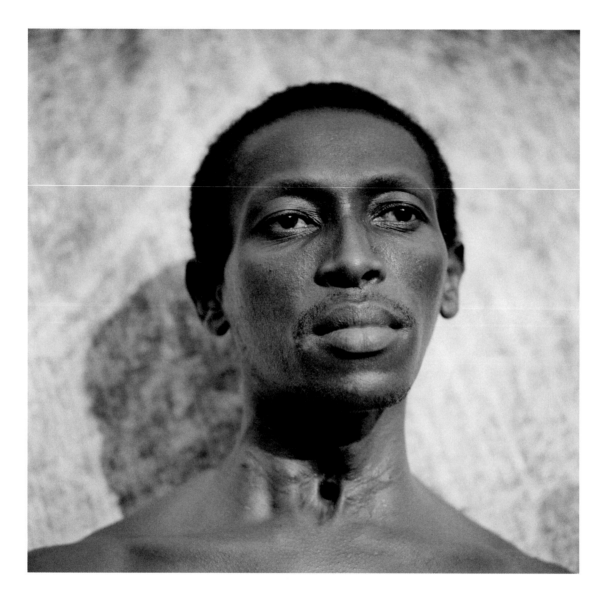

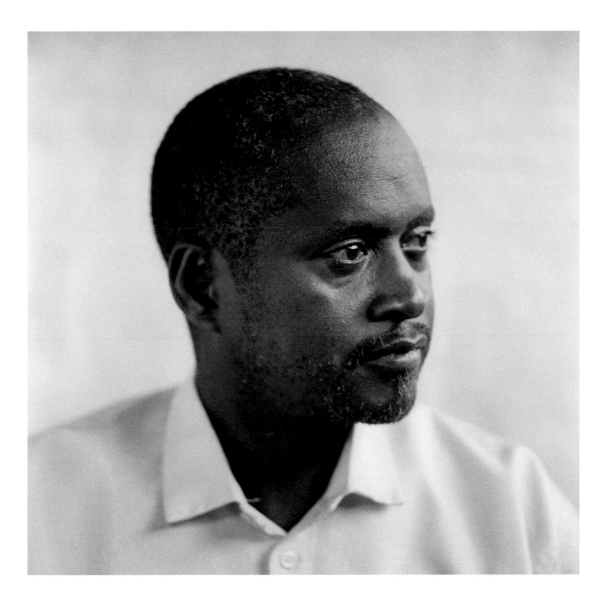

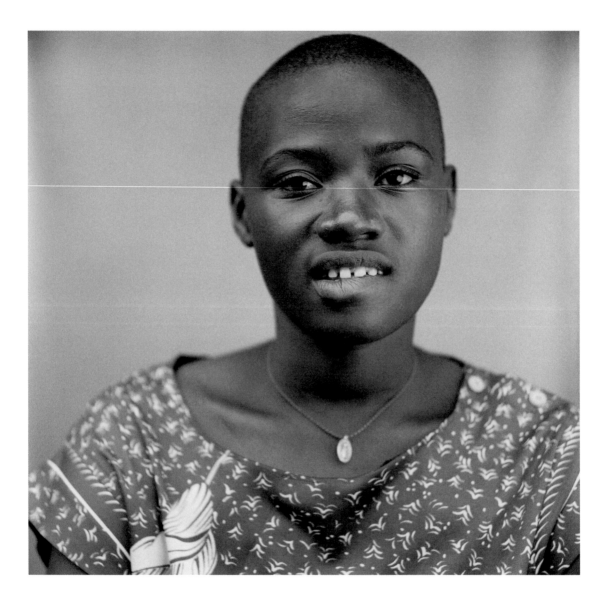

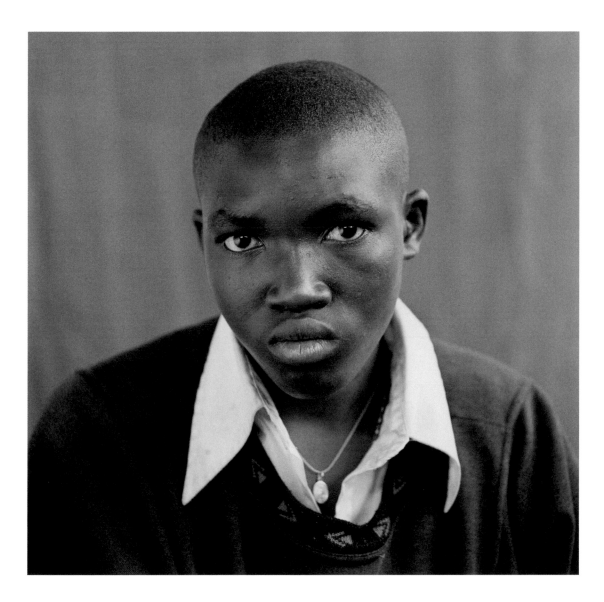

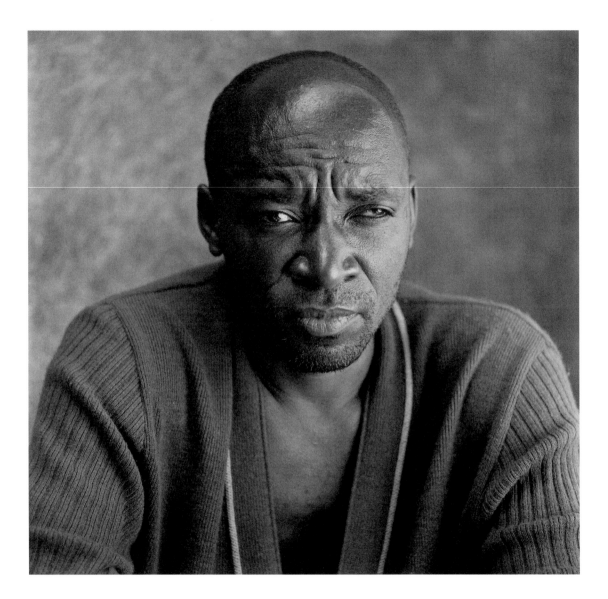

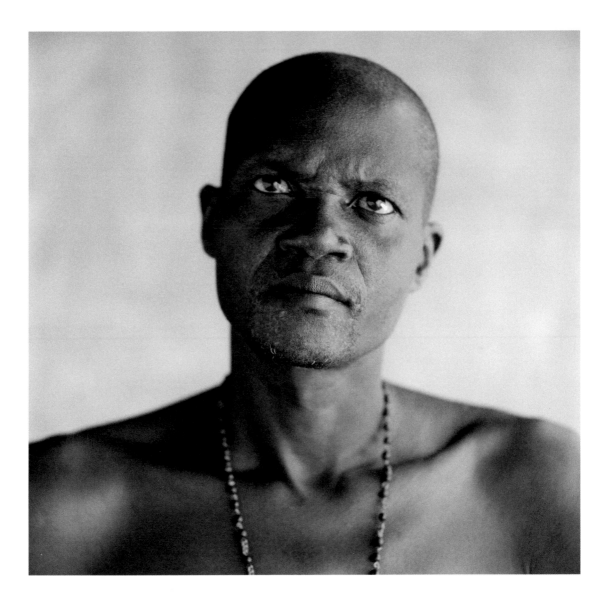

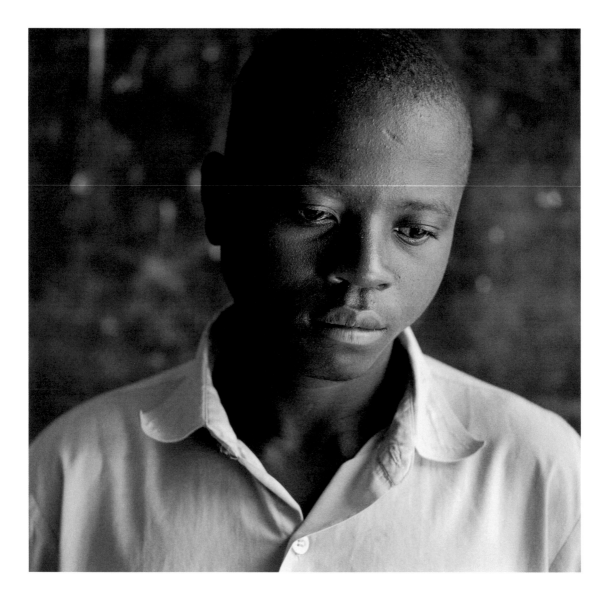

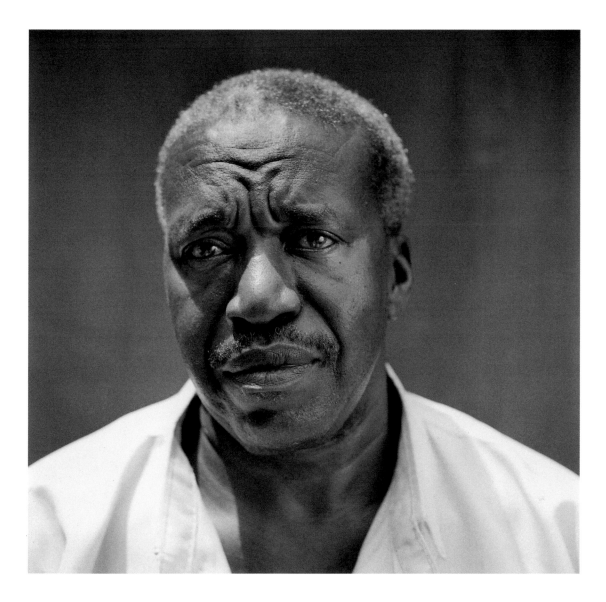

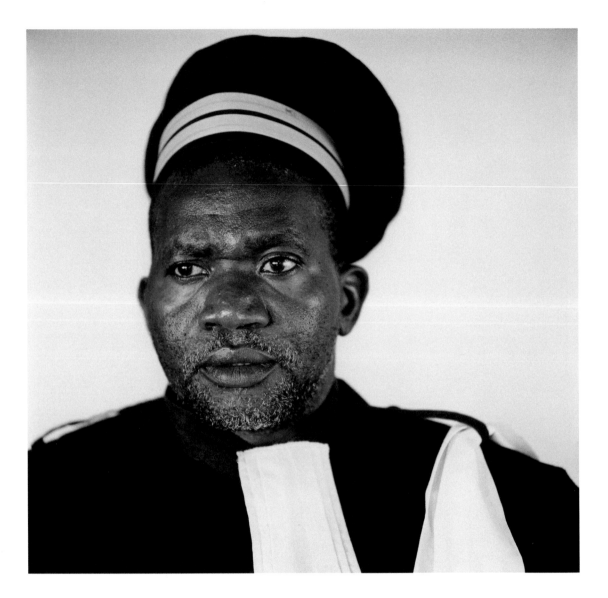

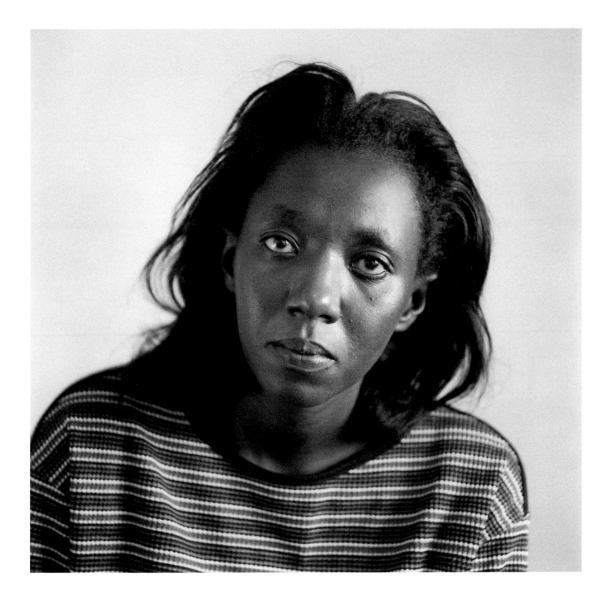

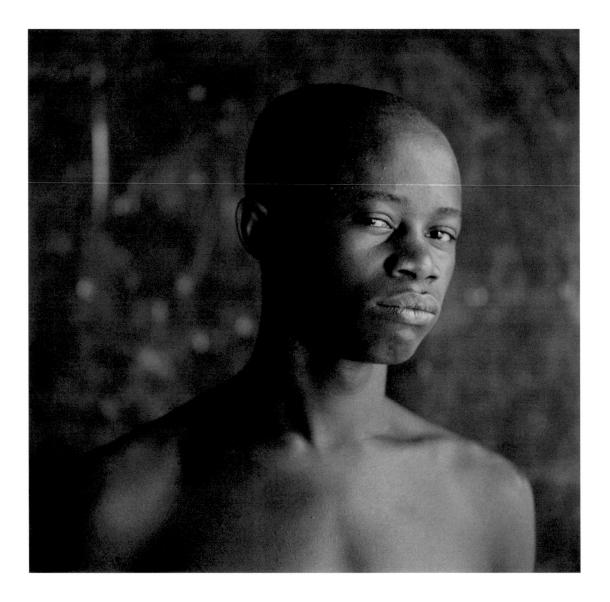

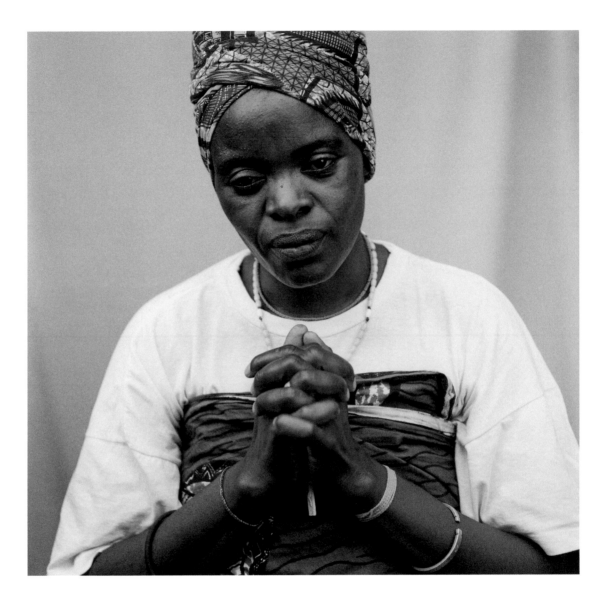

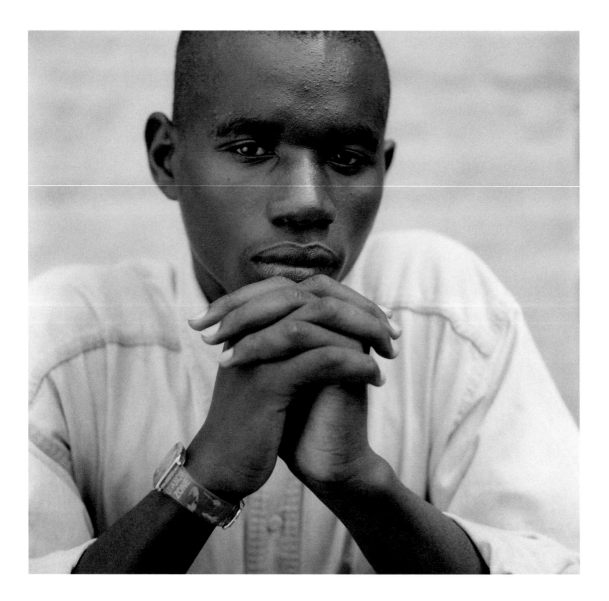

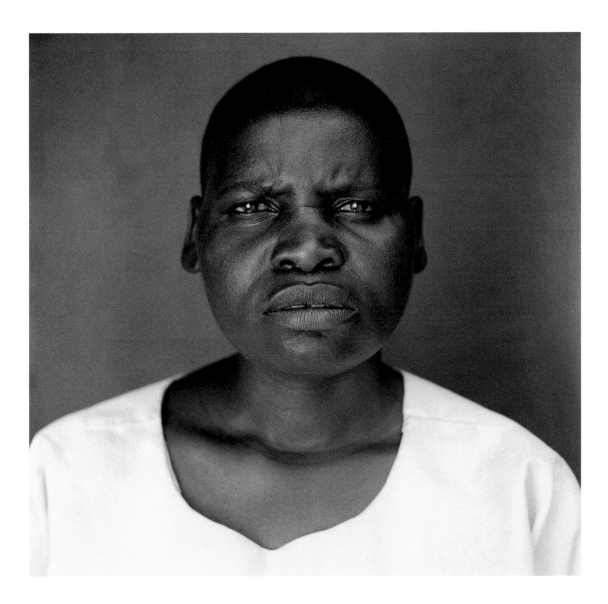

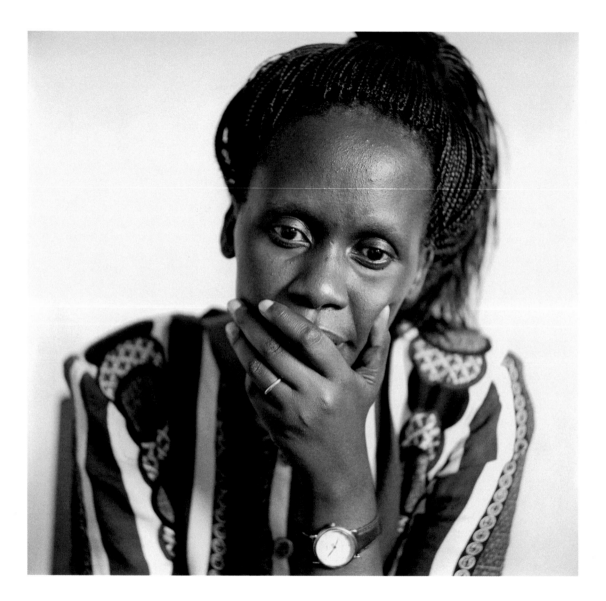

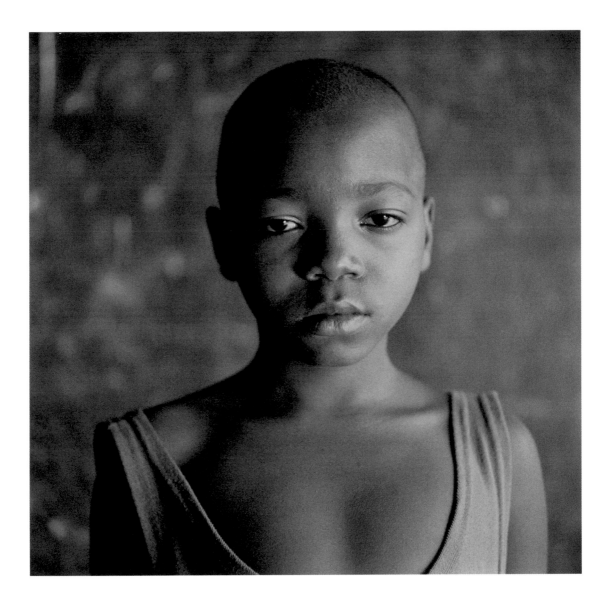

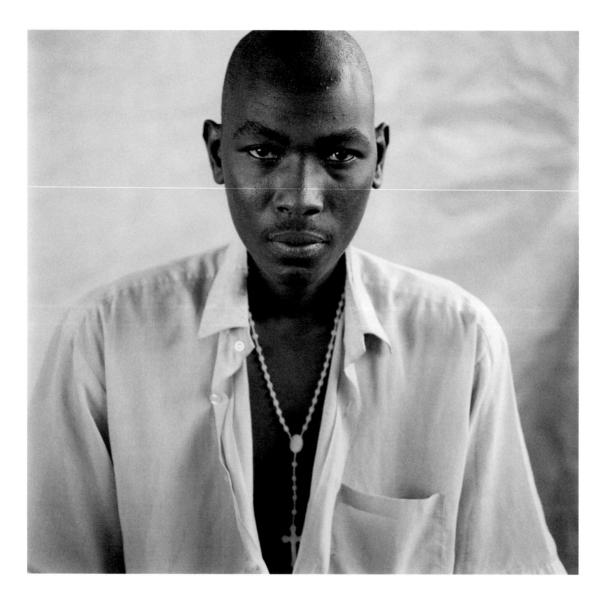

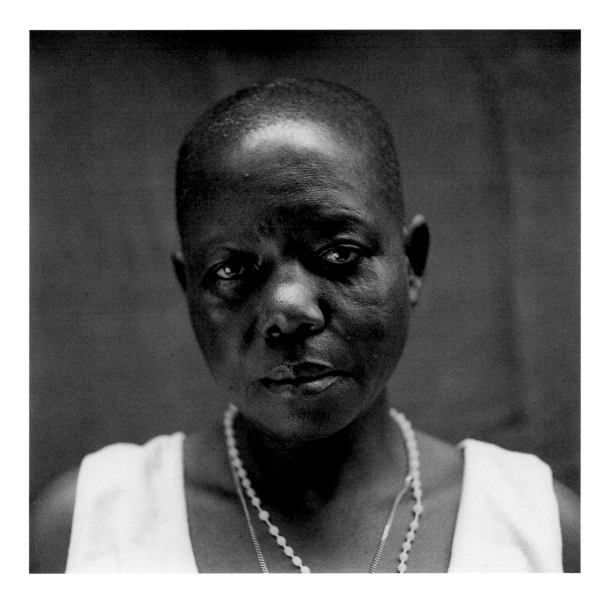

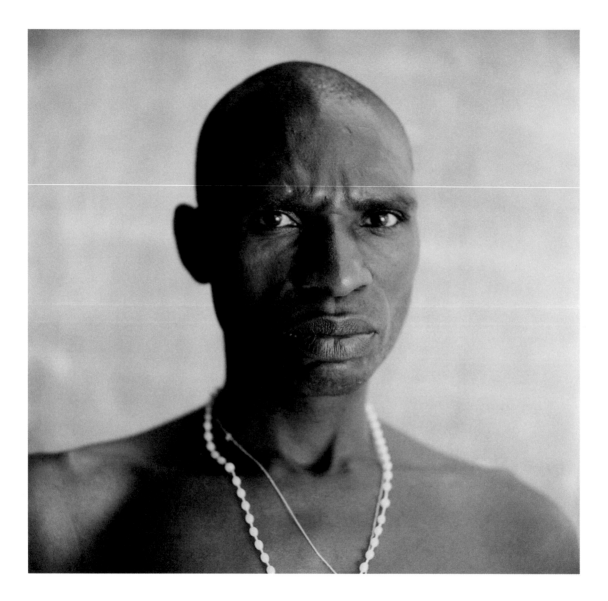

LIST OF PLATES

The information in the captions was collected from
the subjects at the time the photographs were taken.

BANANA TREE, RURAL BUTARE, 1998

2

GÉNOCIDAIRE, WOMEN'S SECTION, GITARAMA PRISON, 1998

3

YOUNG SURVIVOR'S LEG, BUTARE, 2000

4

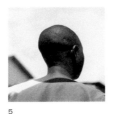

ALECIA KANKUNDIYE, GITARAMA PRISON, 1999

b. 1958
Farmer
Arrested December 18, 1994
Sentenced to life imprisonment April 27, 1999
Confessed Category II *génocidaire*

She was implicated in the deaths of numerous individuals. Accused of participating in an organized group of killers, she confessed, "I saw the people killed, but I do not know how they were killed. They were my neighbors." She subsequently built a house on her neighbors' property.

5

WITNESSES' MICROPHONE, BUTARE COURT OF FIRST INSTANCE, 1999

6

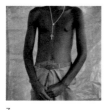

7

GÉNOCIDAIRE, GITARAMA PRISON, 1999

51 L

BUTARE COURT OF FIRST INSTANCE, 1999

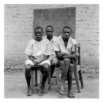

51 R

GROUP, BUTARE PRISON, 1998

Bimenyimana, b. 1961, Sahera, Ngoma
Innocent Rurangirwwa, b. 1957, Sahera, Ngoma
Jean Baptiste Ntawangahera, b. 1966, Sahera, Ngoma
Farmers
Arrested January 1997
Sentenced to death March 1998

These men were charged with constituting a group that committed many murders. When the case came to trial, there were numerous witnesses for the prosecution. They have appealed the verdict.

52 L

COURT RECORDS, BUTARE COURTHOUSE, 1999

52 R

AMIABLE RWIGEMA, 1998

Age: 27
Judge in the Butare Court of First Instance

The majority of judges in Rwanda are young men who have received six months of legal training to prepare them to adjudicate genocide cases. In some instances, the judges are genocide survivors themselves.

67 L

BUTARE COURT OF FIRST INSTANCE, 1999

67 R

GIKONDO PRISON, KIGALI, 1998

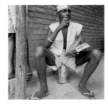

68 L

GIKONDO PRISON, MINORS' SECTION, 1998

68 R

INTERNATIONAL CRIMINAL TRIBUNAL FOR RWANDA,
WITNESS AREA OF COURTROOM, ARUSHA, TANZANIA, 2001

83 L

COURTHOUSE IN BUTARE, 1999

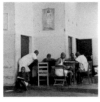

MAIN HALL, KIGALI CENTRAL PRISON, 1999

83R

INTERNATIONAL CRIMINAL TRIBUNAL FOR RWANDA,
FILE FOLDERS, 2001

84L

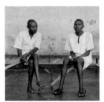

CATEGORY I *GÉNOCIDAIRES*, KIGALI CENTRAL PRISON, 1999

84R

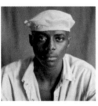

INTERNAL SECURITY GUARD RESPONSIBLE FOR ORDER
WITHIN THE PRISON POPULATION, GIKONDO PRISON,
MINORS' SECTION, 1998

99

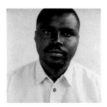

JUSTIN NYANOWI, GITARAMA PRISON, 1999

b. 1968, Nyamabuye
Burgomaster of Musambira
Arrested 1995, awaiting trial

*He has not been tried or confessed and is unsure of the accusations
against him. He states that he fought against the killings until April
20, when the* interahamwe *and ex-FAR came for him.*

100

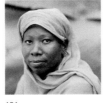

101

JOSEPHINE MUKANYANGEZI, GITARAMA PRISON, 1998

b. 1961, Gisovu, Kibuye
Magistrate in the Kigali Court of First Instance
Arrested September 5, 1994
Sentenced to death August 5, 1998
Category I *génocidaire*

She was accused of inviting the militia to come and kill people even before the genocide began. She was accused of using her telephone to call the various militias, as well as her brother, Obed Ruzindana, who brought the militia. In addition, the militia used her vehicle to hunt people down.

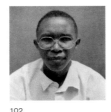

102

JOACHIM HATEGEKIMANA, BUTARE PRISON, 1998

b. 1952, Mbazi, Butare
Government official, deputy prefect since 1980
Arrested 1994

He is alleged to have been involved in the genocide. He has been imprisoned since his arrest and has not been tried or interviewed.

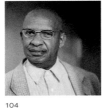

103

JOSEPH NTEGEYINTWALI, KIGALI CENTRAL PRISON, MEN'S SECTION, 1998

b. 1950
Subprefect of Karaba
Arrested December 17, 1996
Sentenced to death November 20, 1998
Category I *génocidaire*

He was accused of genocide, and it was stated that "he was politically responsible for people who fled for safety to his area. He was implicated in the deaths of more than twenty thousand people, as he did nothing to attempt to stop the killings in his area." He fled to Zaire in 1994 and returned to Rwanda in 1996.

104

JEAN DAMASCENE NDAYAMBAJE, BUTARE, 1999

Professor of psychology, National University of Rwanda–Butare
Survivor

He encountered and was captured by soldiers and the militia numerous times. He escaped three times and was hiding in a church in Kigali when the RPF arrived in the city.

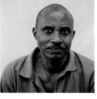

105

J. M. V. SIBOMANA, KIGALI CENTRAL PRISON, 1999

b. 1942, Ruhengeri
Director of the ministry of enviroment and tourism
Arrested February 20, 1997
Sentenced to death May 7, 1999 (also ordered to pay 45,000,000
 Rwandan francs in damages)
Category I *génocidaire*

The specific charges against him were destroying houses, looting, killing, carrying weapons, disturbing public security, destroying documents pertaining to the genocide, and forming a group of killers. He says he is not guilty of the above accusations but did see people kill. He named twenty-five killers, some of whom were arrested, others of whom were killed; witnesses confirm this and say this was his group of killers. He went to Zaire after the genocide and returned in 1996.

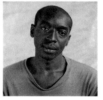

106

NAASSON HATEGEKIMANA, GITARAMA PRISON, 1999

b. 1965, Taba, Gitarama
Primary school teacher
Arrested February 23, 1997
Sentenced to death March 5, 1999

He is accused of taking part in a group that dropped people off a bridge into the river to drown. He was also accused of torturing a child with a hammer and then killing him. He says that this last charge was introduced not at the trial but at his sentencing. He says it was a tragedy that the genocide occurred.

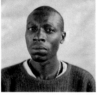

107

BERNARD NIYIBABARIRA, GITARAMA PRISON, 1999

b. 1966, Taba, Gitarama
Primary school teacher
Arrested August 28, 1996
Sentenced to life imprisonment

He took a family to the river to drown. One person — his accuser — survived and argues that his sentence is not fair. Sixteen people were tried together for this crime, and of those, four were released, eleven were sentenced to life imprisonment, and one received the death penalty.

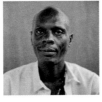

108

GAETAN KABERUKA, BUTARE PRISON, 1998

b. 1954
Driver
Arrested September 21, 1994
Sentenced to death August 1997
Category I *génocidaire*

He was accused of transporting people to be killed. Supposedly forced by the ex-FAR, he brought a group of people to the commune office, where they were murdered. Also, he was accused of organizing and leading groups of killers.

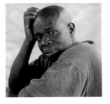

109

INNOCENT RURANGIRWA, BUTARE PRISON, 1998

b. 1957
Farmer and member of a *cellule* committee
Arrested January 1997; he had previously fled to Tanzania and Burundi, returning to Rwanda in 1997
Sentenced to death March 1998
Category I *génocidaire*

He was charged with being part of a group of three (the others were Ntawangaheza and Bimenyimana) who killed many people during the genocide.

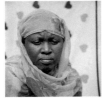

110

MARTIN MUNYANKUMBURWA, GITARAMA PRISON, 1999

b. 1955
Primary school teacher
Arrested October 15, 1994
Sentenced to life imprisonment

He was accused of drowning people in a river.

MARIE GORETH SIYONGIRO, BUTARE PRISON, 1999

b. 1960, Shyanda, Butare
Primary school teacher
Arrested December 27, 1994

She is an alleged génocidaire *and has been in jail since January 25, 1995, but she says she does not know exactly what she is accused of. She visited the prosecutor's office March 1997 for an account of the charges against her. She has seven children, all of whom are free.*

111

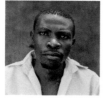

112

JEAN BAPTISTE NTAWANGAHEZA, GITARAMA PRISON, 1998

b. 1966
Farmer
Sentenced to death March 1998
Category I *génocidaire*

He is accused of murder and of being part of a group of three men who killed many people during the genocide. In particular, he participated in atrocities in places such as Ngoma Commune. He has appealed the verdict.

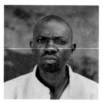

113

ALPHONSE GATERA, GITARAMA PRISON, 1998

b. 1941, Ngoma
Secretary, Project for Agricultural Development,
 Gikongoro Prefecture
Arrested August 26, 1996
Awaiting trial

He fled to Burundi before his arrest. The accusations against him included giving someone up to be killed, keeping a diary with a list of people to be killed, and leading gangs of killers.

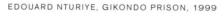

EDOUARD NTURIYE, GIKONDO PRISON, 1999

b. 1949, Kivumu, Kibuye
Catholic priest
Arrested June 30, 1997
Sentenced to death February 14, 1998
Category I *génocidaire*

114

*He was headmaster of a Catholic school in Gisenyi, and people took refuge there after the President's plane crash. He is accused of calling the killers (*interahamwe *and soldiers) and bringing them to the school grounds to kill. About sixty people were massacred. There were few survivors. Evidence also linked him to other killings in the parish in Nyange, where he first fled from Gisenyi. He then fled to Zaire, but he returned to Rwanda and was captured.*

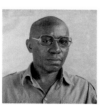

115

DOMINIQUE XAVIER RWESERO, GITARAMA PRISON, 1999

b. 1954, Ruhengeri
Religious printer at a Catholic church in Kigali
Arrested July 10, 1997
Sentenced to death October 28, 1998

He was accused of participating in the killings as an accomplice of the military. Some of his accusers knew him.

116

MARTHA MUKABAGANWA, GIKONGORO PRISON, 2000

b. 1960
Part of the local authority
Sentenced to death, plans to appeal

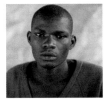

117

RIRIN NIYONSENGA, GITARAMA PRISON, 1999

b. 1977, Kayenze
Unemployed
Arrested May 13, 1998
Category II *génocidaire*

He confessed to being part of a group of killers that drowned a man and his child. He says he was coerced into committing this crime and did it unwillingly. Some members of this group were killed by the RPA. He confessed because someone else who was confessing named him and gave evidence against him.

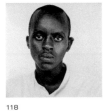

118

SURVIVOR, BUTARE, 2000

Student at the National University of Rwanda–Butare
Member of IBUKA

119

JEAN BOSCO NTIRENGANYA, GIKONDO PRISON, 1998

b. 1980
Former student (one year of primary school)
Arrested September 1997

Charged with involvement in genocide, he is part of the confession program. He confessed in April 1998 that he had killed a ten-year-old girl with a stone, "completing what others had begun." The victim lived in his area, and he knew her.

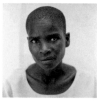

120

DONATA UWIMPAYE, GITARAMA PRISON, 1999

b. 1966
Mother of one child
Arrested November 11, 1994

Accused of taking part in organized group killings, she said that she "brought people to a place where they were killed but did not take part in the killing." When asked if she could kill, she answered, "If I was forced to, if I was told to kill, I would kill."

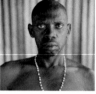

121

CHARLES KARUHIJE, REMERA PRISON, 1998

b. 1948, Kibungo
Primary school teacher
Arrested December 18, 1996
Sentenced to death

The accusations against him included preparing and organizing individuals to use and distribute guns and being an accomplice in looting and murder, as a person in authority who had ordered others to kill.

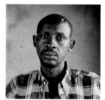

122

EMMANUEL MURANGIRA, MURAMBI MEMORIAL, 2000

b. 1947

He is a survivor of the Murambi killings. "Forty-eight of my relatives were killed here in Murambi. I am the only survivor."

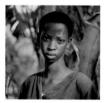

123

AGNES MUKESHIMANA, 1998

Survivor, age 15

Agnes Mukeshimana lives in rural Butare and survived the genocide by hiding in the bush for three months. During that time, she witnessed the killing of a young man fleeing for his life. She occasionally came out of hiding to seek food from an aunt, and during one of these times, she was captured by a group of génocidaires. Miraculously, she managed to escape.

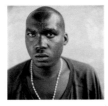

124

ALEXANDRE NYEGUME, GITARAMA PRISON, 1999

b. 1963
Farmer and watchman at the local Catholic church
Arrested December 6, 1996
Sentenced to death August 9, 1997

He was accused of killing a person named Arnola Ntakiba. He was also accused of rape. He has said, "I behaved as a soldier during the genocide," although he was not in the army.

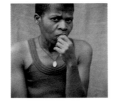

125

JANIVIERE NYIRABAZUNGU, BUTARE PRISON, 1999

b. 1956, Ngoma, Butare
Secretary at Electrogaz (the national water and power company)
Arrested February 24, 1995

She lived in Kigali and is accused of killing people in Ngoma, Butare, but says she was in Kigali at the time. She is also accused of spending three days at the Butare hospital in June 1994 assisting in killing patients there. In particular, she is accused of killing the family of Benjamin Rutayisire. Her husband and children are in Gikongoro.

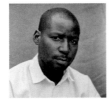

126

JEAN PIERRE MUSHIMYIMANA (A.K.A. NINJA JEAN PIERRE), KIGALI CENTRAL PRISON, 1998

b. 1967, Kibuye
Mason
Arrested December 28, 1996
Confessed Category II *génocidaire*

"We killed people using guns provided by the authorities. Those who gave us guns forced us to perpetrate the crimes. Those who forced us were soldiers of the ex-FAR."

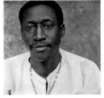

127

DESIRE NGEZAHAYO, GIKONGORO PRISON, 1999

b. 1954, Karama
Burgomaster of Karama
Arrested December 29, 1994
Sentenced to death November 20, 1998
Category I *génocidaire*

He had no specifics on his case but said he had neither killed nor witnessed killings. He was arrested and sentenced for being a burgomaster but has appealed.

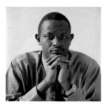

128

PAUL MUGEMANGANGO, GITARAMA, 1998

Prosecutor in Gitarama

He says, "In Gitarama, there is a history of hate politics and previous genocides. I believe that if the society believes in violence [killing], then those who are guilty should know that they may face the death sentence — as a signifier to everyone that genocide cannot be conducted with impunity."

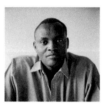

129

FABIAN BUZURORA, GIKONDO PRISON, 1999

b. 1963
Farmer and member of a *cellule* committee
Arrested December 14, 1996
Sentenced to death December 1998

He lived in Musasa, in Kigali-Rural. He was accused of not preventing others from murdering and of being a member of a group of killers. He says that he "never witnessed any killing."

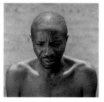

130

AUGUSTIN NKUSI, PRESIDENT OF THE BUTARE COURT
OF FIRST INSTANCE, 1998

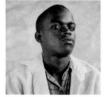

131

STEVE HARERIMANA, BUTARE PRISON, 1998

b. 1947
Butcher (and minor political figure)
Arrested April 21, 1997

He fled to Zaire but returned to Rwanda on April 1, 1997.

132

JEAN DAMASCENE BIZIMANA, GITARAMA PRISON, 1999

b. 1976, Taba, Gitarama
Farmer
Arrested September 9, 1996
Sentenced to life imprisonment March 5, 1999

He participated in drowning eleven members of a family. The judge did not accept him as a minor, so he was tried as an adult. He has appealed his sentence.

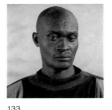

133

JEAN RUTAYISIRE, GITARAMA PRISON, 1999

b. 1962, Taba, Gitarama
Plumber
Arrested September 24, 1996
Sentenced to life imprisonment

He was accused of drowning people.

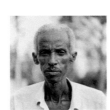

134

SURVIVOR, NYAMATA MEMORIAL, KIGALI, 1998

This man is the caretaker of the memorial; his entire family was killed at Nyamata.

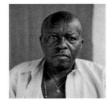

135

DEOGRATIAS GASIMBA, GITARAMA PRISON, 1998

b. 1924, Rutobwe, Gitarama
Businessman, until illness forced him to give it up in 1989
Arrested July 1997
Sentenced to life imprisonment
Category II *génocidaire*

He was accused of helping people kill, especially facilitating their movement by lending them his automobile, and of possessing a gun.

136

J. BOSCO KARANGWA, KIGALI, 1999

Adjoint director, Remera prison

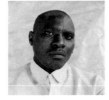

137

CYPRIEN MUNYAKAYANZA, GITARAMA PRISON, 1999

b. 1958, Mugina, Gitarama
Teacher and primary inspector of commune schools
Arrested April 18, 1995
Sentenced to death December 10, 1997

He was one of three people responsible for security in the commune. He is accused of using meetings to plan genocide and, as a "political figure," is held responsible for not protecting people.

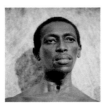

SURVIVOR WITH GUNSHOT WOUND, AVEGA COMPOUND,
KIGALI, 1998

138

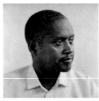

JEAN BAPTISTE GATSINZI, GITARAMA PRISON, 1998

b. 1951, Gikoro
Subprefect in charge of political affairs, Gitarama Prefecture

He was accused as a leader of not protecting people in danger. In addition, he was charged with killing, being a member of a group of killers, and possessing a gun.

139

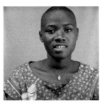

MARIE-CLAIRE UWINEZA, BUTARE PRISON, 1999

b. 1976, Gishamvu, Butare
Secondary school student
Arrested February 14, 1995

She has not been tried but was interrogated and charged with killing in the genocide. She states that the charge against her was "fabricated" by a young man she had refused to marry. He accused her of killing a child whose name she says was just "invented."

140

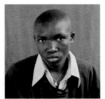

MARCELIN NIYOMWUNGERI, BUTARE PRISON, 1998

b. 1981, Runda, Gitarama
Arrested November 10, 1995

He has not yet been formally charged. His father was beaten to death at Gitarama Prison.

141

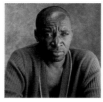

142

MARTIN KAGIMBURA, KIGALI CENTRAL PRISON, MEN'S SECTION, 1998

b. 1954
Primary school teacher
Arrested March 2, 1995
Sentenced to death November 20, 1998
Category I *génocidaire*

He stated that he was accused of killing a neighbor and, later, of participating in a group of killers who attacked people in the Maheresho parish.

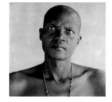

143

ANASTASE NTABARESHYA, REMERA PRISON, 1998

b. 1952 in Kigali-Rural
Mwogo Sector Counselor
Arrested January 2, 1996
Sentenced to death March 26, 1997
Category I *génocidaire*

He did not confess but was tried as a political authority who did not prevent killings. He was also charged with instructing others to kill, organizing groups of killers, and providing guns to groups of killers.

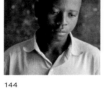

144

ALFRED GATERA, GIKONDO PRISON, 1998

b. 1979
Arrested October 1994
Confessed in July 1998 but has not yet been tried

He confessed to killing four people: two women and two men. He says that he regrets the crimes and did not want to participate in them. He says he was ordered to kill by two interahamwe *and told that if he did not kill the people he would be killed himself.*

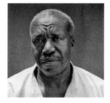

145

GEOFFREY GATERA, GITARAMA PRISON, 1998

b. 1937, Gahini
Medical doctor, interim director of the medical school at the
 National University of Rwanda–Butare
Arrested July 10, 1997
Sentenced to death
Category I *génocidaire*

He was accused of taking patients from the university hospital and bringing them to interahamwe *to be killed. There were numerous witnesses, and the trial — held publicly in Butare — received considerable media attention.*

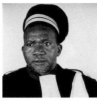

TRIBUNAL JUDGE, BUTARE COURT OF FIRST INSTANCE, 2000

146

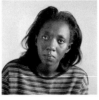

CHANTAL KAYITESI, AVEGA OFFICE, 1998

President of AVEGA, an organization of widows of the genocide
Survivor

147

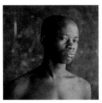

JEAN DE DIEU TWAGIRAMUNGU, GIKONDO PRISON, 1998

b. 1979, Rutongo
Arrested May 26, 1995

*Confessing to his crimes in April 1998, he said he had killed a girl
with a machete on April 10, 1994. He says he was forced to kill the
girl by the* interahamwe, *who also beat him.*

148

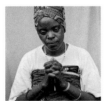

BEATRICE MUNTUNGIRE, BUTARE PRISON, 1999

b. 1955
Farmer
Arrested April 11, 1995

She is an alleged génocidaire *but awaits formal charges. Neighbors
have said that she participated in the genocide and was involved
in the death of her husband. She has denied all the allegations,
especially those connected with her husband's death. She says, "I
believe that I am in prison because of jealousy, that someone wants
to steal my crops and land."*

149

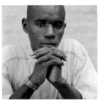

SURVIVOR, BUTARE, 1998

150

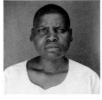

151

ANCILLE MUKAMINEGA, KIGALI CENTRAL PRISON, 1998

b. 1958, Binga
Farmer
Arrested February 1998
Confessed Category II *génocidaire*

She killed her own children. She has said that a group of killers, catching her and her children as they attempted to flee, told her that she could kill the children or the group would kill them on their return. She broke into her parents' house and found poison, which she used to kill her three children.

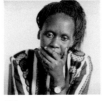

152

ESTHER MUJAWAYO, AVEGA OFFICE, KIGALI, 1998

Founding member of AVEGA

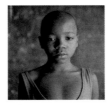

153

BONIFACE MBONYIZIMA, GIKONDO PRISON, MINORS' SECTION, 1998

b. 1986
Arrested May 1998
Confessed *génocidaire*

He was accused of killing an old woman from his village, a neighbor. The only eyewitness was the victim's son. He confessed to his crime because he "heard that those who confessed would be released."

Prison officials estimated that there are over twenty-one hundred detainees who were under the age of criminal responsibility (fourteen years of age, according to Rwandan law) during their involvement in the genocide. Some have no relatives anymore, and many of those who have families have been abandoned for fear of the possible consequences of harboring criminals, their children.

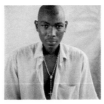

154

INNOCENT MUSABYIMANA, GITARAMA PRISON, 1999

b. 1978
Farmer
Arrested February 9, 1995
Confessed Category II *génocidaire*

He confessed on August 14, 1998, that he had killed a three-year-old child. He says, "I confessed because I was sorry for what I did, it was wrong." He acknowledged that he did not know the child but knew the mother, who was his neighbor.

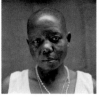

155

EUPHRASIE KAMATAMU, KIGALI CENTRAL PRISON, 1998

b. 1944
Local administrator, Muhima, Kigali
Arrested 1997
Sentenced to death
Category I *génocidaire*

She stated during her trial that she knew nothing about the killings and that her only crime was that she worked in the local political administration. It was proven at her trial that, in fact, her home, office, and vehicle had been used by the interahamwe *to plan and facilitate the killings. Many witnesses stated under oath that she was at the checkpoints identifying those to be killed and was intimately involved with the planning and implementation of the genocide.*

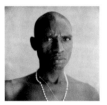

156

CHARLES NKURIKIYINKA, REMERA PRISON, 1998

b. 1952
Accountant for the Musasa commune
Arrested November 9, 1994
Sentenced to death August 28, 1997
Category I *génocidaire*

He was accused of initiating the idea of killing patients in the dispensary at the commune.

190–191

ANNIVERSARY OF THE GENOCIDE, KIGALI, APRIL 2000

MAP

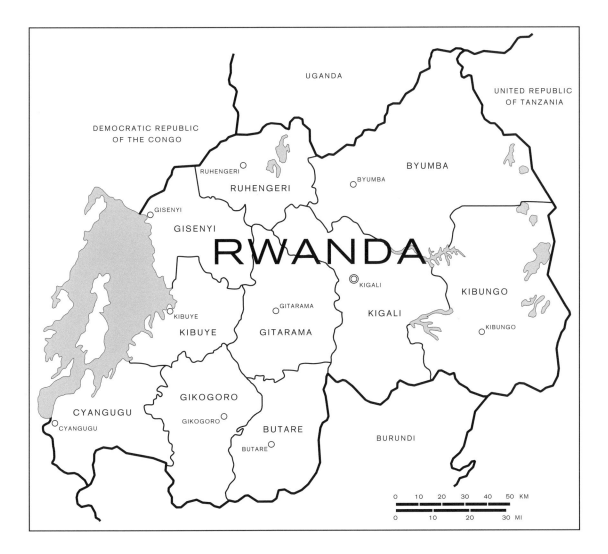

GLOSSARY

BAGOGWE

A subgroup of Tutsis in the northwest of Rwanda who were attacked and killed in large numbers in 1990.

BRIGADIER

The commander of a small police force within the territory of a commune.

BURGOMASTER

The administrative leader of a commune, similar to the mayor of a town.

CABARET

A rural bar.

CDR: COALITION POUR LA DEFÉNSE DE LA RÉPUBLIQUE (COALITION FOR THE DEFENSE OF THE REPUBLIC)

The hard-line, Hutu nationalist political party.

CELLULE OR CELL

The smallest administrative unit in Rwanda. A committee of members, led by a *responsable,* runs each *cellule.*

CENTER

A commercial focal point in rural Rwanda, often located at a crossroads, and usually where rural markets are held.

COMMUNE

An administrative unit, comparable to a town.

CONSEILLER OR COUNCILOR

The administrative leader of a sector.

FAR: FORCES ARMÉES RWANDAISES (RWANDAN ARMED FORCES)

The Rwandan government army.

FRW: *FRANCS RWANDAIS* (RWANDAN FRANCS)

Rwandan money. In early 1994, one U.S. dollar was worth about 140 FRW.

GENDARME

Police officer in the national police force.

GÉNOCIDAIRE

A perpetrator or participant in the genocide.

GUTSEMBASEMBA

A Kinyarwanda word that means to destroy completely.

IGITERO

A Kinyarwanda word meaning attack.

INKOTANYI

A usually neutral Kinyarwanda word that refers to the RPF rebels, often translated as "fierce warrior."

INTERAHAMWE

The MRND youth wing, some members of which were trained as militias prior to the 1994 genocide. The Kinyarwanda word roughly translates as "those who work together with the same goal."

INYENZI

A usually derogatory Kinyarwanda word that refers to the RPF rebels and their supporters. The term literally means "cockroaches," and it was also used to refer to the Tutsi rebels who attacked Rwanda in the 1960s.

**JDR: JEUNESSE DÉMOCRATIQUE RÉPUBLICAINE
(REPUBLICAN DEMOCRATIC YOUTH)**

The MDR youth wing.

**MDR: MOUVEMENT DÉMOCRATIQUE RÉPUBLICAINE
(DEMOCRATIC REPUBLICAN MOVEMENT)**

The largest domestic opposition party, strongest in central, southern, and southwestern Rwanda.

MRND: MOUVEMENT RÉVOLUTIONNAIRE POUR LA DÉVELOPPEMENT (NATIONAL REVOLUTIONARY MOVEMENT FOR DEVELOPMENT)

Rwanda's ruling party, led by former president Juvénal Habyarimana, strongest in northern and northwestern Rwanda.

PL: PARTI LIBÉRAL (LIBERAL PARTY)

An opposition political party often supported by Tutsis living in Rwanda before the genocide.

PSD: PARTI SOCIAL DÉMOCRATE (SOCIAL DEMOCRATIC PARTY)

An opposition political party with support in southern Rwanda.

RESPONSABLE

The administrative leader of the *cellule* committee.

RPA

Rwanda Patriotic Army, the military wing of the RPF.

RPF

Rwandan Patriotic Front, the largely Tutsi diasporic rebel movement that attacked Rwanda and ignited civil war in 1990.

SECTOR

An administrative unit that is smaller than a commune and larger than a *cellule*.

UBWOKO (PLURAL *AMOKO*)

A Kinyarwanda word that technically refers to some type of categorical distinction but in practice often refers to different ethnic groups. *Ubwoko* thus refers to the Hutu and Tutsi ethnic categories but also to, for example, different automobile manufacturers (such as Toyota versus Mitsubishi).

ACKNOWLEDGMENTS

This project could not have been realized without the help of numerous individuals and institutions. I would like to thank them for all their support and encouragement along the journey. To begin with, I would like to thank Rwanda's Ministry of Justice for its efforts and support in granting me access to the prisons in Rwanda. In particular, Gerald Gahima was instrumental in obtaining permission for me to begin the project. For their support and for allowing me to make my first images in Rwanda, I thank Esther Mujawayo and Chantal Kayitesi, the co-founders of the Association of Widows of the Genocide (AVEGA-Agahozo). They helped me find the courage to start the image-making process. Numerous others in Rwanda assisted me, and I wish to thank them as well: Trish Hiddleston, Emmanuel Batungwanayo, Vincent Sezibera, Odette Nyiramilino, and Simion Rwagersore, the chief prosecutor of Rwanda.

In the United States, several people were instrumental from the conception of the project. Philip Gourevitch willingly gave me help with contacts and information for my initial trips to Kigali. The support, intellect, and belief of Thomas Keenan, at the Human Rights Project at Bard College, were indispensable. Special thanks go to Mahnaz Ispahani, formerly of the Ford Foundation, who, from her initial view of the work, was supportive and encouraging—especially by helping to arrange for assistance for the project through the Institute of International Education in New York. I could not have continued without Jody Ranck, formerly of the Human Rights Center at the University of California at Berkeley, who has been a close confidant, friend, and educator in many aspects of my research. I wish to thank him for his continued support and encouragement of and belief in my work and this project, and for the many hours spent discussing and writing about the work.

For their support of this project and continued counsel on many issues, I thank Adam Bartos, Robert Benjamin, Christina Roessler, Bill Arnold, John Hubbard, Beth Lyons, Bill Levinson, Sandy and Harvey Lew-Hailer, Tod Gangler, Denzil Hurley, and especially Mariam Stephan, whose belief in this work and in me has been so very important throughout the project.

I would also like to thank my gallerists: Elizabeth Leach, of the Elizabeth Leach Gallery, in Portland, Oregon; Paul Kopeikin, of the Paul Kopeikin Gallery, in Los Angeles; Elizabeth Strong and Emma Brogi, of the Photographer's Gallery, in London; Liz Mayer, of Winston Wachter Fine Art, in New York; and Wim Melis, of Noorderlicht, in Groningen, the Netherlands.

In particular, I want to express my deep gratitude to Jeff L. Rosenheim, the associate curator in the Department of Photographs at the Metropolitan Museum of Art, whose insight and advice have been invaluable; Stephen Shore of Bard College, for sharing his thoughts about sequencing the work for publication; and finally Artist Trust, in Seattle, for providing financial support at critical junctures for the completion of the project.

Finally, I thank my editor, Ramona Naddaff, and the entire staff at Zone Books for their perseverance and professionalism in producing this book.

Robert Lyons

Intimate Enemy never would have happened without the initiative and support of Michel Feher. Ramona Naddaff, Meighan Gale, and Gus Kiley from Zone Books provided important encouragement and suggestions throughout the process. Aloys Habimana helped me with translations from Kinyarwanda and answered many questions. While I was in Rwanda, Théogène Rwabahizi provided extraordinary research assistance. Lars Waldorf, Ben Siddle, and Eithne Brennan provided much friendship, support, and good humor in Kigali when I would return from a week of interviews. The research and writing for the project was generously supported with fellowships from the Social Science Research Council, the Center for African Studies at the University of California, Berkeley, and the Graduate School at the University of Wisconsin, Madison. Robert Lyons's photographs captivated me the first time I saw them, and inspired me through this project. Finally, I must thank Sara Guyer, who not only coped patiently with my many months away in Rwanda, but also encouraged this project and suggested the book's title. All that said, the usual caveats apply: all faults herein are my own.

Scott Straus

Design & typesetting by Julie Fry
Separations by Thomas Palmer
Printed by Meridian Printing
Bound by Acme Bookbinding

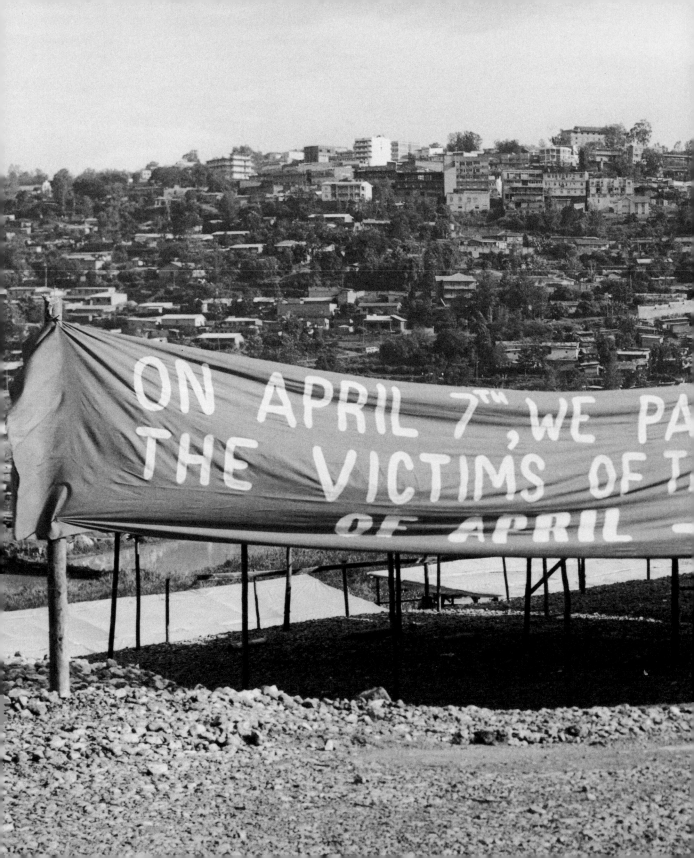

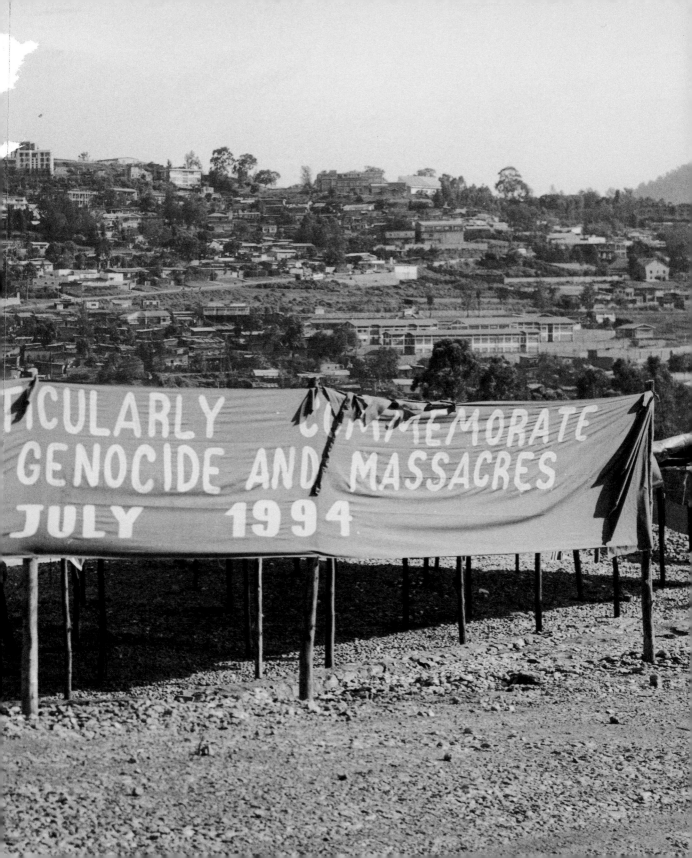